IMAGES OF BASEBALL

THE PAWTUCKET RED SOX

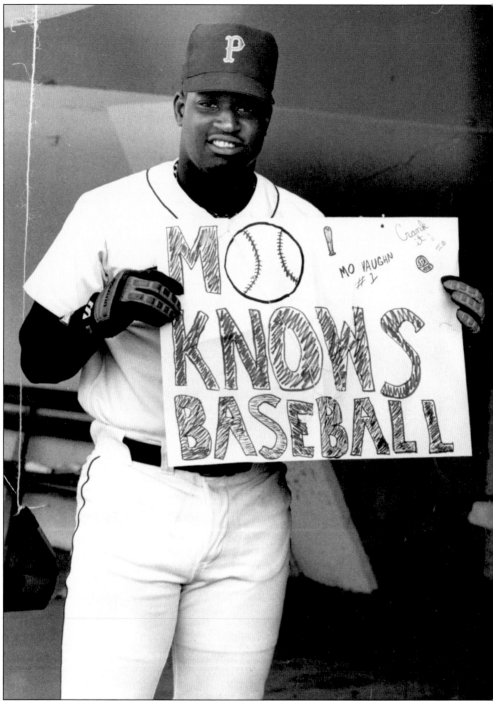

Mo Vaughn was a hit at the plate for the PawSox in 1990, when he hit .295 with 22 home runs and was named the team's most valuable player (MVP). Vaughn went on to a successful career with the Boston Red Sox (where he was the American League MVP in 1995), Anaheim Angels, and New York Mets. As this picture indicates, he was also a big hit with the fans. (L.M.Z., courtesy Pawtucket Red Sox.)

IMAGES OF BASEBALL

THE PAWTUCKET RED SOX

David Borges

ARCADIA
PUBLISHING

Published by Arcadia Publishing
Charleston, South Carolina

Printed in the United States of America

Library of Congress Catalog Card Number: 2002111592

For all general information contact Arcadia Publishing at:
Telephone 843-853-2070
Fax 843-853-0044
E-mail sales@arcadiapublishing.com
For customer service and orders:
Toll-Free 1-888-313-2665

Visit us on the Internet at www.arcadiapublishing.com

This book is dedicated to my mother, Patricia Borges,
who has always believed in me.

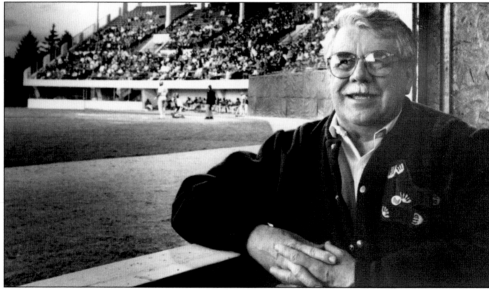

Ben Mondor saved the Pawtucket Red Sox franchise—twice. He purchased the team in 197
and quickly turned a floundering franchise into one of the most successful in minor-leagu
baseball, winning an International League pennant that very first year. In the late 1990.
Mondor oversaw the McCoy Stadium renovation project, which transformed McCoy into on
of baseball's best parks. (Courtesy Pawtucket Red Sox.)

CONTENTS

ACKNOWLEDGMENTS

Very special thanks go to Ben Mondor, Mike Tamburro, Lou Schwechheimer, Bill Wanless and the entire Pawtucket Red Sox staff for their help in the production of this book. Also special thanks go to Paul Palange, publisher of the *Pawtucket Times* and the *Woonsocket Call*, for permission to use photographs from the *Times'* library; to Jeanne Murphy and Greg Murphy for use of photographs taken by the late Jim Murphy; and to Mike Pappas, for use of photographs from his collection. Photographers whose work was used in this book are Rich Dugas, Antoine Boulanger, Ralph E. Smith, Butch Adams, Louriann Mardo-Zayat, Ken Love, Barbara Jean Germano, and John Supancic. Photographic credits are listed at the end of each caption whenever possible and indicated by the photographer's initials (R.D. for Rich Dugas, R.E.S. for Ralph E. Smith, and so on).

INTRODUCTION

On January 28, 1977, Ben Mondor officially purchased the Pawtucket Red Sox. The franchise was never the same again.

Pawtucket won the International League pennant in 1977, went to the International League Governor's Cup finals the following year, and kicked off a rousing quarter-century run at McCoy Stadium as one of the most popular sporting attractions in all of New England. After drawing just over 70,000 fans in 1977, Pawtucket attracted more than 600,000 fans during the 2001 season.

Of course, the Pawtucket Red Sox existed before Mondor and Mike Tamburro, the team's longtime president, took over the reins. In fact, professional baseball was being played at McCoy Stadium some 30 years before Mondor's arrival. The Pawtucket Slaters, a Class B affiliate of the Boston Braves, called McCoy home during the late 1940s; the Pawtucket Indians, Cleveland's Double-A affiliate, played there in 1966 and 1967.

The first incarnation of the Pawtucket Red Sox emerged in 1970 as the Boston Red Sox' Double-A affiliate and under the ownership of Joe Buzas. Three years later, Pawtucket became Boston's Triple-A franchise and won the Junior World Series title that very first year. But the good times were short lived.

Despite consistently churning out talented young players who would contribute greatly to the success of the Boston Red Sox in the 1970s and 1980s, the Pawtucket franchise was soon in dire straits. Buzas sold the team to Phil Anez in 1975. Two years later (one spent as the Rhode Island Red Sox), the franchise was in danger of being moved or folding altogether.

Enter Mondor and a whole new era for the Pawtucket Red Sox—or PawSox, as they have come to be known and loved by so many. Under Mondor's watch, the PawSox have not only become a rousing success both on the field and at the gate, but they have also been involved in some of the most memorable events in New England sports history. There was "the Longest Game" in 1981, a 33-inning affair at McCoy against the Rochester Red Wings that remains the longest game in professional baseball history. There was the Mark Fidrych–Dave Righetti showdown on July 1, 1982; the 1984 Governor's Cup championship team; playoff teams in 1986, 1987, 1991, 1992, 1994, 1996, and 1997; and Tomo Ohka's perfect game in 2000. Of course, there was perhaps the crowning achievement of the Mondor-Tamburro regime: the McCoy Stadium renovation project, which unveiled a sparkling new McCoy on opening night, April 14, 1999, to rave reviews.

Through it all, there have been numerous great PawSox players. Guys like Jim Rice, Fred Lynn, Rick Burleson, Wade Boggs, Bruce Hurst, Roger Clemens, "Oil Can" Boyd, Mike Greenwell, Mo Vaughn, Nomar Garciaparra, and Trot Nixon all went on to stardom in Boston. Guys like Cecil Cooper, John Tudor, Bobby Ojeda, Brady Anderson, Aaron Sele, and David Eckstein went on to find success with other franchises. It is not all about the superstars, either. For every Clemens or Garciaparra there has been a Buddy Hunter, a Chico Walker, a Rick Lancellotti, a Pork Chop Pough—career minor-leaguers who were just as beloved by PawSox fans as the superstars were. There have been guys like Pat Dodson, Sam Horn, and Izzy Alcantara, who were never really able to duplicate their minor-league success at the big-league level.

There have been great opposing players who have made their way through McCoy Stadium over the years, from Cal Ripken Jr. in the Longest Game through Derek Jeter in 1995 to a young prospect like Carl Crawford in 2002. There have been the managers; colorful personalities like

Joe Morgan, Ed Nottle, and Buddy Bailey; and former Red Sox stars like Johnny Pesky, Rico Petrocelli, and Butch Hobson.

McCoy Stadium has often been called the Building of Dreams, where minor-league dreams are one step away from major-league reality. Where fans are able to catch a glimpse of a future baseball star and maybe even get an autograph with one of their "fishing lines," a truly unique McCoy Stadium tradition.

Those dreams were born at McCoy back in 1946 with the Pawtucket Slaters and will continue for many years to come thanks to the Pawtucket Red Sox. There will perhaps be no better example of that than in 2004, when the PawSox and McCoy Stadium host the Triple-A All-Star Game.

One

THE EARLY YEARS AT MCCOY STADIUM: 1942–1972

McCoy Stadium had a hard time getting off the ground. In fact, it nearly sank *into* the ground. It was built on a swamp called Hammond's Pond, and during construction, the city of Pawtucket had to replace 60 massive concrete pillars that sank into the swampy quicksand beneath the stadium.

Many did not want the stadium built at all. When Mayor Thomas P. McCoy began building the project in 1938, opponents decried the millions of dollars in contracts awarded to the mayor's allies. Its $1.5 million cost supposedly exceeded that of the Rose Bowl, and the new stadium was dubbed "McCoy's folly."

Nevertheless, on July 4, 1942, McCoy Stadium was officially dedicated. Four years later, the Pawtucket Slaters became the first prime tenant at McCoy, as a Class B affiliate of the Boston Braves. The Slaters went 70-54 in their inaugural season, good for fourth place in the New England League, and stayed in Pawtucket for four years. Future big leaguers like George Crowe, Johnny Logan, and Chuck Tanner donned Slater uniforms before the New England League folded in 1950. Professional baseball did not return to McCoy Stadium for another 17 years.

In the interim, McCoy became a "shameful eyesore," according to a *Pawtucket Evening Times* article in 1961. However, by 1966, professional baseball was back at McCoy, this time in the form of the Pawtucket Indians.

A Double-A affiliate of the Cleveland Indians, the team struggled in its two years at McCoy, finishing 68-71 in 1966 and 67-71 in 1967. One of the Indians' top players was Dave Nelson, who went on to play for 10 seasons in the majors. The Pawtucket Indians folded after two seasons, however, and McCoy Stadium was again without a professional tenant—though not for too long.

In 1970, the Pawtucket Red Sox took form as Boston's Double-A affiliate. Under the ownership of Joe Buzas, the Double-A PawSox finished in fourth place in their inaugural season in the Eastern League (1970) and third the next two years in the four-team American Division. The team boasted plenty of future major-league stars during that time, including future Hall of Famer Carlton Fisk, as well as Rick Burleson, Rick Miller, and Juan Beniquez, and laid the groundwork for the great success the team would have in 1973, its first season at the Triple-A level.

Mayor Thomas P. McCoy ran Pawtucket with an iron fist. According to the *Rhode Island Free Press*, McCoy created "one of the most powerful and ruthless political machines ever forged in this state" during his nine years as mayor. He died on August 15, 1945 (the same day the Japanese surrendered to the Allies, ending World War II), but not before leaving his lasting gift to the city: McCoy Stadium. (Courtesy Pawtucket Public Library.)

This is how McCoy Stadium looked in the late 1940s, when it served as the home field for the Pawtucket Slaters.

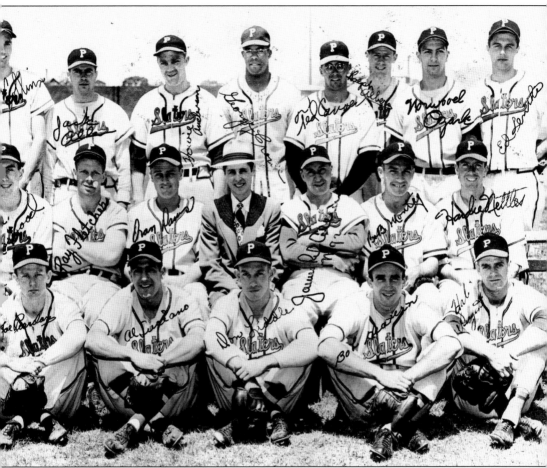

Professional baseball made its debut at McCoy Stadium in 1946 in the form of the Pawtucket Slaters, a Class-B affiliate of the Boston Braves. The Slaters were managed by Rip Collins and went 70-54 in their inaugural season, good for fourth place in the New England League. Among their star players was George Crowe (top row, fourth from left), the team's only African American player a year before Major League Baseball was integrated. Crowe did not get a shot in the majors until 1952; in 1957, at the age of 36, the big first baseman clubbed 31 homers, and he wound up playing 10 major-league seasons. The Slaters stayed in Pawtucket for four years finishing fourth place two more times, then going 52-26 in the first half of the 1949 season and 31-17 in the second half) before the New England League folded in 1950. Professional baseball did not return to McCoy Stadium for another 17 years. (Courtesy Mike Pappas.)

This is McCoy Stadium as it looked in 1957. The outfield grass looks like the dusty terrain of a desert. (Courtesy *Pawtucket Times*.)

Graffiti lines the exterior doors of McCoy Stadium in this June 1961 photograph. In an accompanying article in the *Pawtucket Evening Times*, McCoy was called a "shameful eyesore." (Courtesy *Pawtucket Times*.)

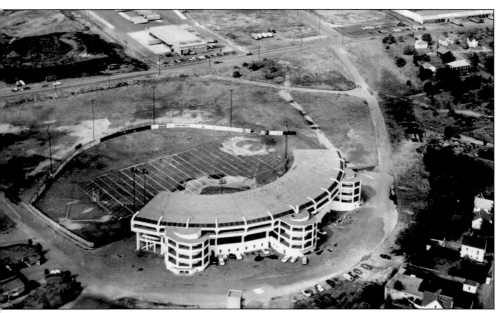

This is an aerial view of McCoy Stadium on September 1, 1966. Note the football gridiron spanning the field. McCoy served as the home for three different Pawtucket high school football teams at this time. (Courtesy *Pawtucket Times*.)

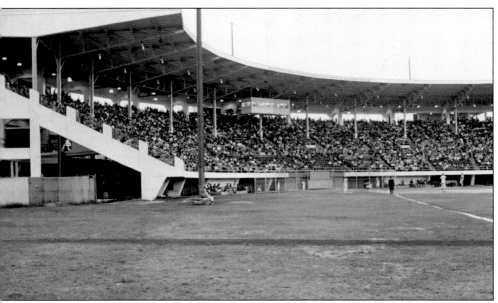

A full house packs McCoy to take in a Pawtucket Indians game on July 1, 1967. (Courtesy *Pawtucket Times*.)

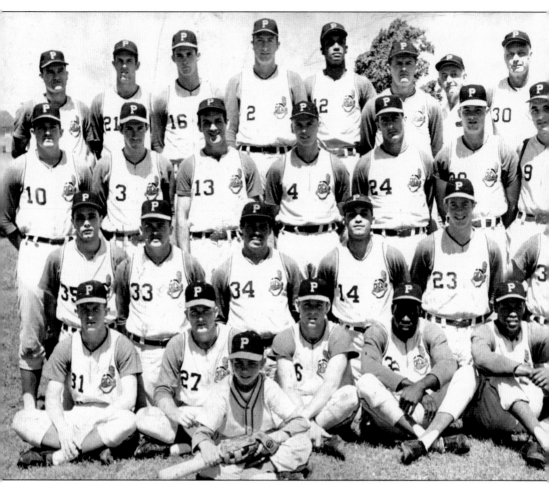

Professional baseball returned to Pawtucket and McCoy Stadium in 1966, when the Pawtucket Indians came to town. A Double-A affiliate of the Cleveland Indians, the team struggled in its two years at McCoy, finishing 68-71 in 1966 (though that was good for second place in the Eastern League) and 67-71 in 1967 (fifth place). Pictured, from left to right, are the following: (first row) Randy Carroll, George Woodson, bat boy Pete Menard, Richie Scheinblum, Johnny Parker, and Dave Nelson; (second row) Jim Rittwage, Dick Almes, Sam Parrilla, Luis Isaac, Mike Hedlund, and Russ Nagelson; (third row) Jim Wingate, Gary Oring, Harold "Gomer" Hodge, Jerry Kelly, Steve Bailey, Harold Kurtz, and Bill Wolfe; (fourth row) June Raines, Gary Boyd, Fran Healy, Dick Brosagh, Tony Martinez, Roy Kuhl, trainer Bill Snell, and manager Clay Bryant. (Courtesy Mike Pappas.)

Dave Nelson played with the Pawtucket Indians in 1966 and made his major-league debut two years later with Cleveland. Nelson went on to play 10 big-league seasons with Cleveland, the Washington Senators, Texas Rangers, and Kansas City Royals. He was an American League All-Star with Texas in 1973, when he hit .286 with 41 stolen bases. Nelson is currently a roving minor-league instructor with the Milwaukee Brewers. (J.M., courtesy Greg Murphy.)

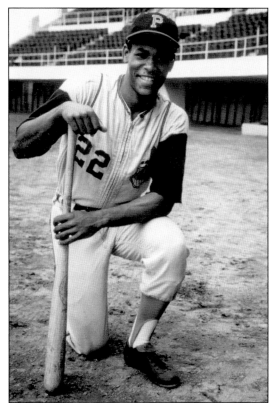

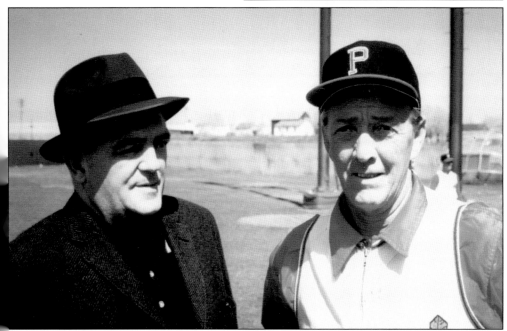

John "Red" Davis (right) skippered the Indians to a 67-71 record, fifth-place finish in 1967. He is pictured here with longtime *Pawtucket Times* sportswriter and editor Ted Mulcahey. (J.M., courtesy Greg Murphy.)

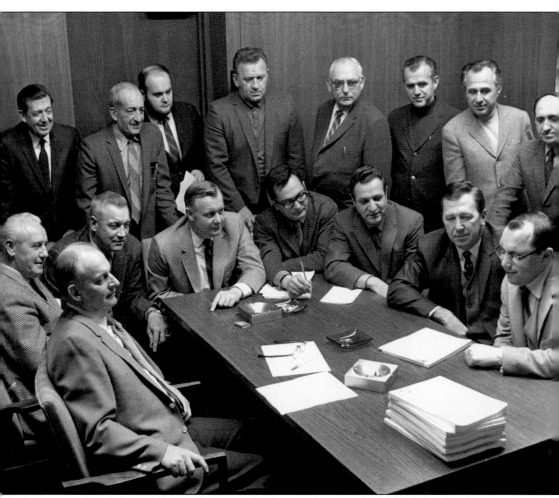

In a crowded room in 1970, Joe Buzas (seated, second from right) meets with leaders of the city of Pawtucket as the Pawtucket Red Sox are about to start up as the Double-A affiliate of Boston. Also present at this meeting are former major-leaguers and Rhode Island natives Hank Soar (seated, third from left), Chet Nichols (seated, fourth from left), and Max Surkont (standing, fourth from left). Buzas is seated next to PawSox general manager Steve Daley (seated, far right). (Courtesy Mike Pappas.)

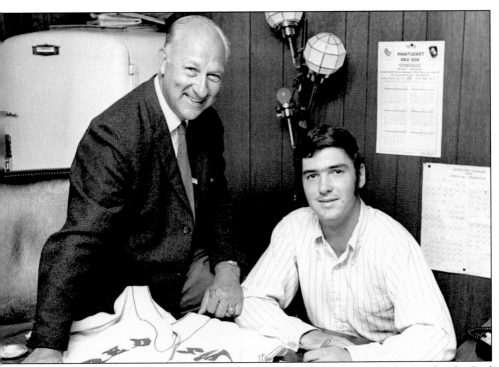

3ill "Lefty" Lefebvre, a Rhode Island native, former big-league pitcher, and scout for the Red Sox, signs another Rhode Islander, John LaRose, to his first professional contract on June 13, 970. It took LaRose, a Cumberland product, six more years to pitch for his hometown team, he PawSox. He was an International League All-Star in 1978. (Courtesy *Pawtucket Times*.)

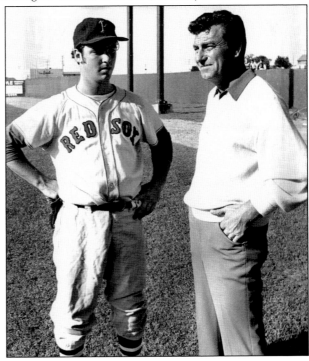

Darrell Johnson (right) chats with John LaRose shortly after LaRose signed a professional contract in June 1970. Three years later, Johnson managed Pawtucket to the Junior World Series title. The following season, he was named manager of the Boston Red Sox and guided them to the American League pennant and a trip to the 1975 World Series, where the Sox lost to Cincinnati in one of the greatest World Series of all time. (Courtesy *Pawtucket Times*.)

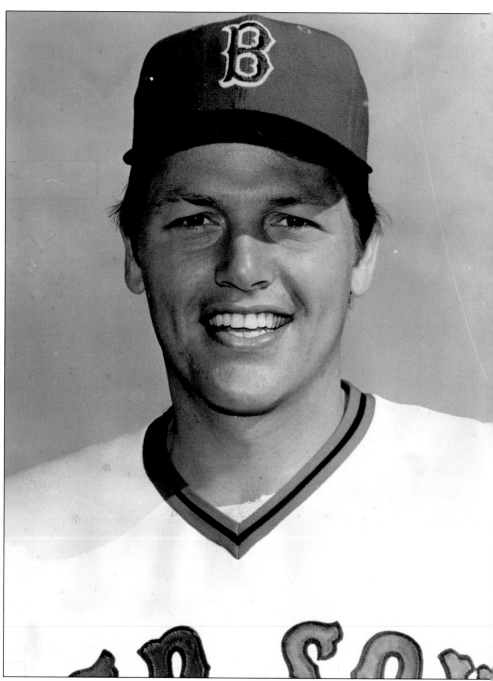

Carlton Fisk spent the 1970 season with Pawtucket. While battling injuries, the catcher hit 1
homers in 93 games and displayed the type of deftness behind the plate that earned him a call-u
to Boston out of Triple-A Louisville the following season. In 1972, Fisk was the American League
Rookie of the Year after hitting .293 with 22 homers. That was the start of a 24-year major-league
career with Boston and the Chicago White Sox (1981–1993) that saw him earn 11 All-Star berth:
hit more home runs than any catcher in history and, in 1999, become the first PawSox alun
inducted into the National Baseball Hall of Fame. (Courtesy Pawtucket Red Sox.)

Looking more like the team's bat boy in this July 1970 photograph, Juan Beniquez (left) eventually won an International League batting title with the PawSox in 1973 (.298) and went on to a 17-year major-league career with eight different teams: Boston (1971 and 1972–1975), Texas (1976–1978), the Yankees (1979), Seattle (1980), California (1981–1985), Baltimore (1986), Kansas City (1987), and Toronto (1987–1988). On the right is John Clifton. (Courtesy *Pawtucket Times*.)

Billy Gardner was Pawtucket's manager in 1971, and he led the team to a 63-76 record and a third-place finish in the Eastern League. In 1981, Gardner was named skipper of the Minnesota Twins, a position he held for four and a half seasons. He also managed the Kansas City Royals for part of the 1987 season. (Courtesy *Pawtucket Times*.)

In a rare wedding ceremony at McCoy Stadium in September 1971, Pawtucket Red Sox pitcher Max Oliveras is married. Oliveras and his new bride prepare to walk down the aisle (above) and make their exit through raised bats by Oliveras's Pawtucket teammates (below). (J.M., courtesy Greg Murphy.)

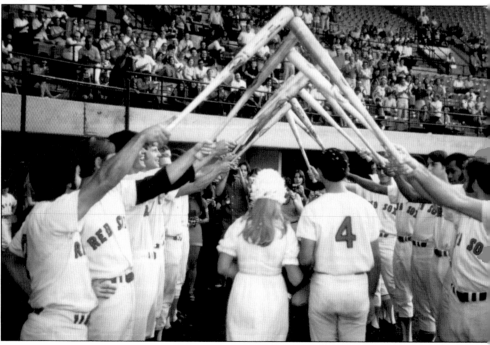

Two
TRIPLE-A PROMOTION: 1973–1976

In 1973, the Boston Red Sox moved their top minor-league franchise from Louisville, Kentucky, to Pawtucket, Rhode Island (though oddly, the PawSox did not officially become Boston's Triple-A affiliate until 1975).

While McCoy Stadium's facilities were barely even at Double-A standards, the first-ever Triple-A incarnation of the Pawtucket Red Sox was one of the best in franchise history. The team was stacked with future big-league stars like Cecil Cooper, Rick Burleson, Lynn McGlothen, and Juan Beniquez and managed by Darrell Johnson, who guided Boston to the World Series just two years later. Future superstars Jim Rice and Fred Lynn also earned late-season call-ups from the Double-A franchise in Bristol that year.

Pawtucket went 78-68 in the regular season, good for second place in the International League. They defeated the Charleston Charlies in the opening round of the playoffs and advanced to the Junior World Series, where Pawtucket topped the Tulsa Oilers of the American Association, four games to one. Tulsa, the St. Louis Cardinals' Triple-A affiliate, featured future batting champion Keith Hernandez on its roster.

In 1974, Jim Rice put together one of the greatest seasons in Pawtucket Red Sox history. The South Carolina–born slugger won the International League's Triple Crown with a .337 batting average, 25 homers, and 93 RBIs and was named the league's MVP. A year later, he and Lynn (who hit .282 with 21 homers in 1974) were the "Gold Dust Twins," rookies who helped guide Boston to the American League pennant.

Also in 1974, Joe Morgan began his run as dean of PawSox managers—a nine-year term that saw him win more games (601) than any other skipper in franchise history. Still, Pawtucket finished in last place in 1974, 31.5 games out of first place, and in January 1975, Buzas sold the team to Phil Anez, a local advertising executive. In 1976, the team's name was changed to the Rhode Island Red Sox. Jack "Home Run" Baker belted 36 homers, a franchise record that was not matched for 25 years, but the team had fallen on hard times.

By November 1976, Anez was threatening to move the team to New Jersey. In December, the franchise was awarded to Marvin Adelson after Anez became embroiled in financial woes. Just a month later, however, the International League withdrew its offer to Adelson, who had threatened to move the team to Worcester, Massachusetts.

The franchise was bankrupt, deprived of its membership in professional baseball and in a state of disarray. But help was on the way in the form of a retired businessman who had made a career out of buying, restoring, and selling bankrupt businesses: a man named Ben Mondor.

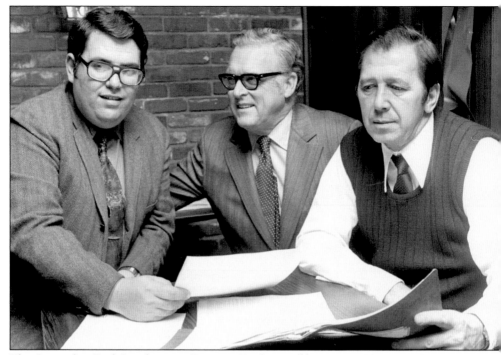

The Pawtucket Red Sox became Boston's Triple-A affiliate in 1973. Here, PawSox general manager Neil Bennett (left) and owner Joe Buzas (right) look over paperwork with International League president George Sisler Jr., son of the Hall of Famer. (Courtesy *Pawtucket Times*.)

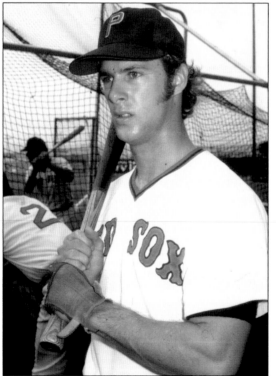

After leading the Eastern League in putouts and fielding average (.961) for Double-A Pawtucket the year before, Rick Burleson was the linchpin of Pawtucket's 1973 team. The scrappy shortstop led the International League with 146 games played and hit .252. By the following season, he was Boston's starting shortstop, a title he held for seven solid seasons before he and Butch Hobson were traded to the California Angels after the 1980 season. In 13 major-league seasons, Burleson compiled a .273 batting average and was a four-time All-Star. (Courtesy Pawtucket Red Sox.)

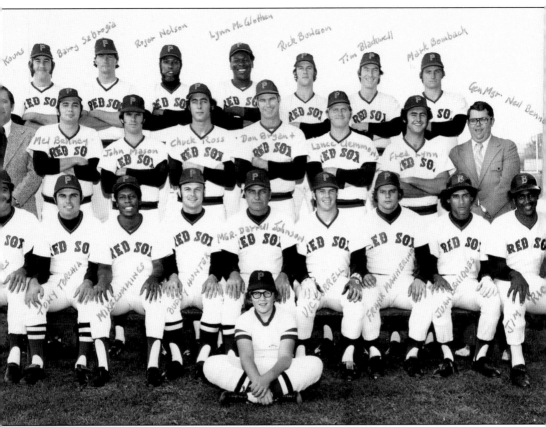

With numerous future big-league standouts on the team, it is easy to see why the 1973 Pawtucket Red Sox won the Junior World Series, beating the Tulsa Oilers in five games. Pictured here, from left to right, are the following: (front row) Frank Vazquez, Tony Torchia, Mike Cummings, Buddy Hunter, manager Darrell Johnson, an unidentified bat boy, Vic Correll, Frank Manhering, Juan Beniquez, and Jim Rice; (middle row) president-owner Joe Buzas, Mel Behney, John Mason, Chuck Ross, Don Bryant, Lance Clemmons, Fred Lynn, and general manager Neil Bennett; (back row) Bill Kouns, Barry Sabrogia, Roger Nelson, Lynn McGlothen, Rick Burleson, Tim Blackwell, and Mark Bomback. Cecil Cooper, not pictured here, was a key member of the club. (Courtesy Mike Pappas.)

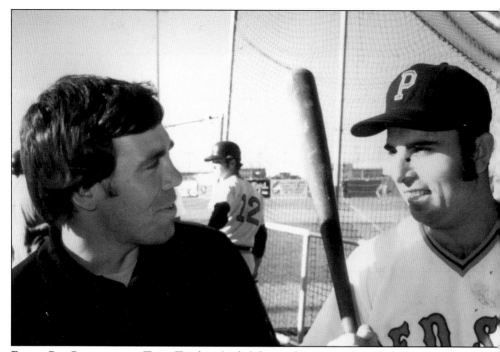

Future PawSox manager Tony Torchia (right) began his Pawtucket Red Sox career in 1970 when he led all Eastern League first baseman in fielding. He played for the Triple-A Pawtucket squad for two seasons, including the 1973 championship campaign. In 1974, Torchia set franchise record with 28 pinch-hit at-bats, which still stands. Two years later, he emerged as the manager of Winston-Salem team in the Carolina League. (J.M., courtesy Greg Murphy.)

Bill Kouns played three seasons with Pawtucket. He never made it to the majors, but he did throw Pawtucket's second no-hitter of the 1973 season on August 2 in a seven-inning game at Richmond. (Courtesy *Pawtucket Times*.)

Pawtucket owner Joe Buzas helps new manager Joe Morgan try on his new team jacket after Morgan was named the team's manager in 1974. Morgan, a Walpole, Massachusetts native who had managed in the Pittsburgh Pirates' system the previous eight years, began a nine-year career as the PawSox skipper in 1974. "Walpole Joe" guided the PawSox to the International League title in 1977, when he was named the league's Manager of the Year, and won more games (601) than any other PawSox manager. (Courtesy *Pawtucket Times*.)

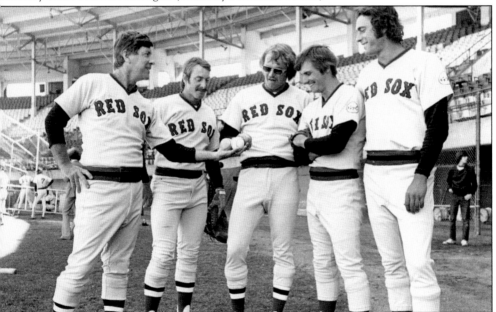

Joe Morgan (left) chats with players (from left to right) Tim Blackwell, Dick Pole, Mark Bomback, and Chuck Ross in this 1974 picture. Pole had one of the dominant pitching seasons in Pawtucket history in 1973, leading the team with 12 wins, 158 strikeouts, and a 2.03 ERA. He also threw the franchise's first-ever no-hitter in a seven-inning game on June 23 against Peninsula and earned the International League's Most Valuable Pitcher award. In 1974, Ross threw the franchise's third no-hitter in a little over a year. (Courtesy *Pawtucket Times*.)

25

Simply put, Jim Rice had one of the greatest seasons in minor-league baseball history with the Pawtucket Red Sox in 1974. Rice, who had been called up to Pawtucket from Double-A Bristol at the end of the 1973 season, won the International League's Triple Crown with a .337 batting average, 25 homers, and 93 RBIs and was also the league's MVP in 1974. A year later, Rice and fellow Pawtucket alum Fred Lynn were baseball's "Gold Dust Twins," a pair of rookies who helped the Boston Red Sox win the American League pennant. That kicked off a fantastic 16-year career for Rice, during which he won an American League MVP award (1978), led the loop in home runs three times, and hit 382 career round-trippers. (J.M., courtesy Greg Murphy.)

red Lynn was also an International League All-Star outfielder in 1974, when he hit .282 with 21 homers and 68 RBIs for Pawtucket. The following year with Boston, he hit .331 with 21 homers and 105 RBIs and beat out fellow "Gold Dust Twin" Jim Rice as the American League's MVP *and* Rookie of the Year. Lynn had six strong seasons in Boston (winning the American League batting title in 1979) before being traded to the California Angels in 1981. The six-time All-Star ended his 17-year major-league career after the 1990 season with 306 career home runs. (Courtesy Pawtucket Red Sox.)

Tim Blackwell was a catcher for Pawtucket in 1974 and made his big-league debut with Boston that year. He was sold to the Philadelphia Phillies in April 1976 and wound up fashioning a 10-year major-league career with four different teams: Boston, Philadelphia, Montreal, and the Chicago Cubs. (Courtesy *Pawtucket Times*.)

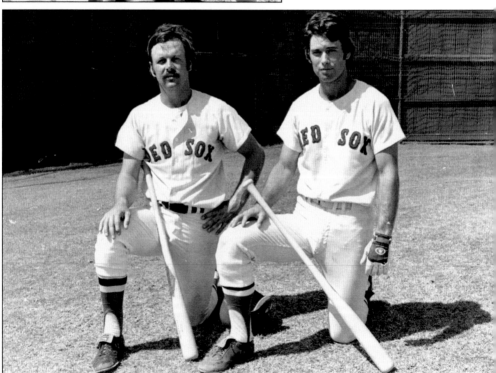

Harold "Buddy" Hunter (left), pictured here with Kim Andrew, spent several seasons with the PawSox (1973, 1975–1979) and was popular as a player, coach, and team captain. Through it all, he got just 17 big-league at-bats with Boston. (Courtesy *Pawtucket Times*.)

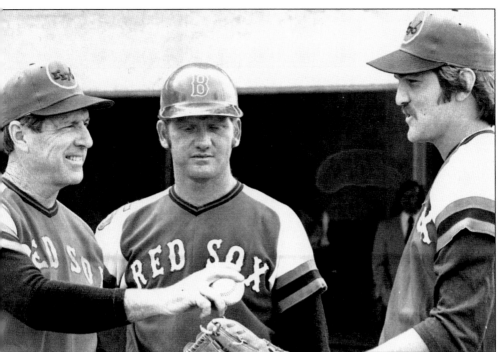

Joe Morgan hands the ball to Don Aase, the ace of Pawtucket's staff in 1975, while Andy Merchant looks on. Aase won eight games and led Pawtucket with 125 strikeouts in 1975. He spent parts of the next two seasons in Pawtucket. He was promoted to the Boston Red Sox in July 1977 but was traded to the California Angels in the off-season. Aase continued a successful career that lasted 13 years and included an All-Star appearance with Baltimore in 1986. (Courtesy *Pawtucket Times*.)

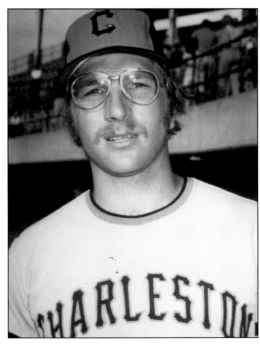

Do you recognize this Charleston Charlie at McCoy *c*. 1975? It is Ken Macha, who became the manager of the PawSox 22 years later. (J.M., courtesy Greg Murphy.)

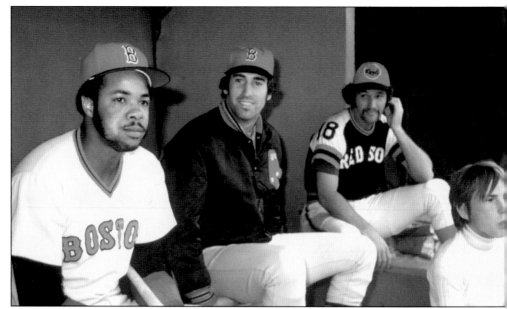

Prior to the annual PawSox–Red Sox Alumni Game in June 1976, former Pawtucket standout Cecil Cooper (left) sits in the visitor's dugout. Cooper led Pawtucket with 15 homers and 77 RBIs in the 1973 championship season. The following year, he was up in Boston, beginning a standout, 14-year run as a first baseman with the Red Sox (1974–1976) and Milwaukee Brewers (1977–1987), during which he hit .298 with 241 career home runs and was a five-time All-Star. (J.M., courtesy Greg Murphy.)

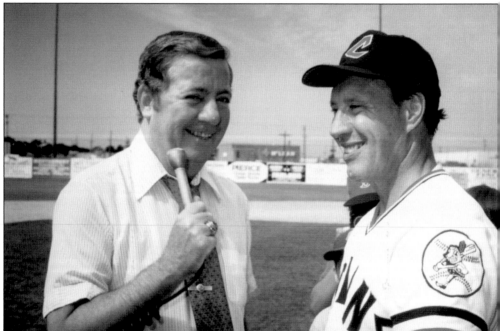

In August 1976, Hall of Fame pitcher Bob Feller (right) made a visit to McCoy Stadium as part of a promotional event. Here, Feller is interviewed by local broadcasting legend Chris Clark. (J.M., courtesy Greg Murphy.)

ack "Home Run" Baker certainly earned his nickname. In 1976, the big first baseman belted 36 home runs, a franchise record that remained untouched for 25 years until Izzy Alcantara tied it in 2001. Baker was a career minor-leaguer who got two very brief cups of coffee with the Red Sox. After eight years in the minors, Baker ended his playing career in 1978. (Courtesy Pawtucket Red Sox.)

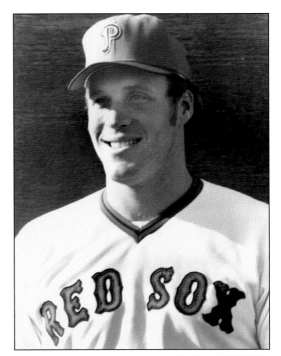

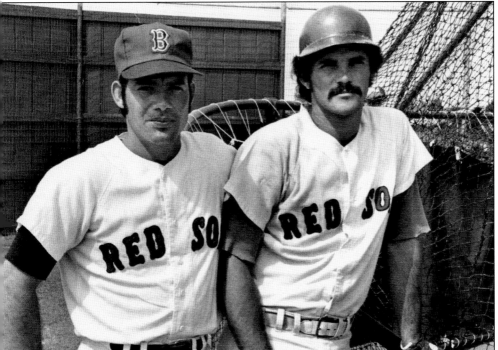

Bo Diaz (right), pictured here with infielder Ramon Aviles, was the catcher for the PawSox in 1976 and 1977. He began a 13-year major-league career in 1977 that saw him play for four different teams (Boston, Cleveland, Philadelphia, and Cincinnati). Tragically, Diaz was killed while fixing the roof of his home in Caracas, Venezuela, on November 23, 1990. He was 37. (Courtesy *Pawtucket Times*.)

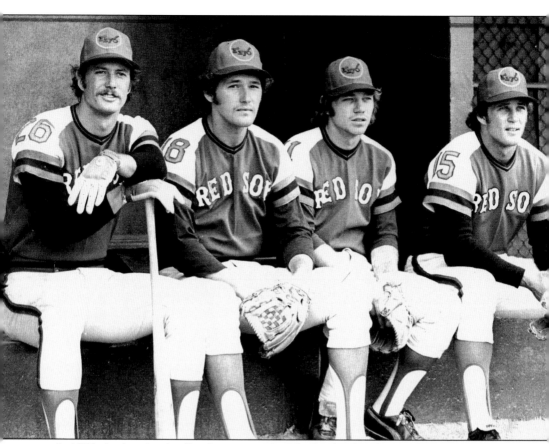

In 1976, the franchise's official name was the Rhode Island Red Sox. These members of the 1976 Rhode Island Red Sox team (complete with their signature RI 76 hats) are, from left to right, Richard Sharon, John Balaz, Dave Machemer, and Butch Hobson (the future PawSox and Red Sox manager). Hobson was an International League All-Star third baseman in 1976, when he hit 25 homers in just 90 games before being called up to Boston. A year later, he hit 30 homers as the No. 9 hitter in Boston's lineup. Hobson managed the PawSox for one successful season (1991). He was the Red Sox manager from 1992 to 1994. (Courtesy *Pawtucket Times*.)

Three

A New Owner, a New Beginning: 1977–1999

Ben Mondor was a retired businessman who had built up a reputation for buying bankrupt businesses, but he did not know what he had gotten himself into when he purchased the Pawtucket Red Sox on January 28, 1977. The franchise was bankrupt, deprived of its membership in professional baseball, and McCoy Stadium was in terrible shape. But, change came quickly with Mondor.

First, he hired Mike Tamburro, an intern with the team three years earlier, as the team's general manager. Then, Mondor and Tamburro cleaned up McCoy, turning it into a first-class facility. The results were immediately successful, and the PawSox won the 1977 International League pennant. After Pawtucket beat the Richmond Braves in four games in the first round of the playoffs, they were swept by the Charleston Charlies in the International League Governor's Cup finals. Although they attracted just 70,354 fans through the turnstiles in 1977, Pawtucket saw its attendance number grow nearly twofold the next season and increase gradually over the next five seasons.

In 1978, Pawtucket finished in second place but went to the Governor's Cup finals again, this time losing to the Richmond Braves in seven games. In 1979, Pawtucket's leadership triumvirate was complete when Lou Schwechheimer began work as a college intern. Six years later, he was promoted to vice president and general manager.

In 1981, the PawSox forever etched their name into the record books when they competed in the longest game in professional baseball history. The game began on a cold Easter Eve, April 18, at McCoy Stadium between the PawSox and Rochester Red Wings. The teams played 32 innings that night before International League commissioner Harold Cooper finally ordered the game halted at 4:09 a.m. When the game resumed on June 23, major-league players were on strike, so the eyes of the sports world were on McCoy Stadium. A throng of 5,765 fans jammed the 6,000-seat stadium, and media outlets from all over the world—including the BBC and the Sunday *Mainichi* newspaper from Japan—were in attendance.

The resumption of the game did not last long. Dave Koza lofted a soft line drive that easily scored Marty Barrett with the winning run in the bottom of the 33rd inning—832 pitches and 13 at-bats after the game had begun.

The PawSox won their first-ever Governor's Cup title in 1984 under manager Tony Torchia. After losing the first two games of the best-of-five series at home against the Maine Guides, the PawSox had to travel up to Old Orchard Beach, Maine, and win all three games. They did just that, winning game five 3-0. It completed a "worst-to-first" turnaround for the PawSox, who had the worst record in all of Triple-A baseball (56-83) a year earlier.

The PawSox continued to have success on the field over the next 15 years, qualifying for the playoffs seven times, including three first-place finishes. Through it all, numerous future big-league stars filed through McCoy: Wade Boggs, Roger Clemens, Mike Greenwell, Mo Vaughn, Aaron Sele, Nomar Garciaparra, and Trot Nixon, just to name a few.

The PawSox remained a popular attraction, but there was something missing. McCoy Stadium did not meet Professional Baseball Agreement standards of having at least 10,000 seats. The stadium also was not handicap-accessible. McCoy was in need of a facelift, and the McCoy Stadium renovation project was born.

The new bosses in town for the PawSox in 1977 were Ben Mondor (left) and Mike Tamburro. Mondor bought the team in January of that year, hired Tamburro as general manager, and the two helped transform a bankrupt franchise into one of the most successful in all of minor league baseball. The PawSox drew just 70,000 fans in 1977, despite winning the International League title; in 2001, the team welcomed over 600,000 fans through the turnstiles. (Courtesy Pawtucket Red Sox.)

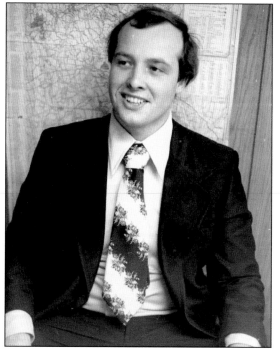

Mike Tamburro first came to the PawSox as an intern in 1974. He ran the Red Sox' Class-A affiliate in Elmira, New York, for the next two years and then returned to Pawtucket in 1977 at new owner Ben Mondor's urging. Tamburro became the team's general manager, overseeing the day-to-day operation of the club. He was named the Executive of the Year by both the International League and the *Sporting News* after the PawSox' 1984 Governor's Cup championship season and again in 1988 by the International League. (Courtesy Pawtucket Red Sox.)

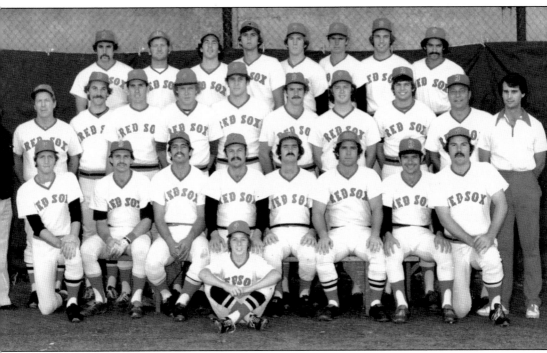

The 1977 Pawtucket Red Sox won the International League regular season championship with an 80-60 record. The PawSox defeated the Richmond Braves three games to one in their opening-round playoff series but were swept by the Charleston Charlies in the International League finals. Members of the team in this photograph are, from left to right, as follows: (front row) Jimmy Wright, Dave Coleman, Rick Berg, Buddy Hunter, bat boy Jim Joyce, John LaRose, Gary Allenson, Ramon Aviles, and Jim Vosk; (middle row) owner Ben Mondor, manager Joe Morgan, Rich Waller, Jim Burton, Allen Riley, Jack Baker, Dave Stapleton, Bruce Poole, Ted Cox, pitching coach Johnny Podres, and trainer Dale Robertson; (back row) Chuck Rainey, Andy Merchant, Wayne Harer, Glenn Hoffman, John Tudor, Win Remmerswaal, Dave Koza, and Poochy Delgado. (Courtesy Pawtucket Red Sox.)

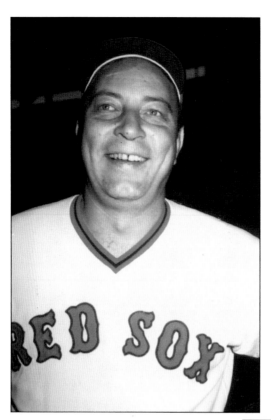

Former Brooklyn Dodger World Series hero Johnny Podres served as the PawSox pitching coach briefly during the mid-1970s. (J.M., courtesy Greg Murphy.)

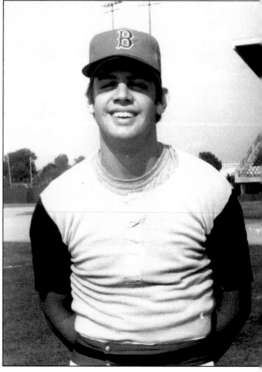

Ted Cox was the star of the PawSox' 1977 International League championship team. Cox drove in a team-high 81 runs and was named the league's MVP and All-Star third baseman. His success earned him a whirlwind late-season promotion to Boston, where he hit .362 in 13 games. He was traded to the Cleveland Indians after the season. (Courtesy Pawtucket Red Sox.)

Sam Bowen began a long PawSox career in 1977, when he led the club with 15 homers. Bowen spent six seasons in Pawtucket, leading the team in homers three more times (including 28 in 1979) and earning International League All-Star recognition in 1981. Through it all, however, Bowen saw action in a grand total of 16 major-league games with the Red Sox. (Courtesy Pawtucket Red Sox.)

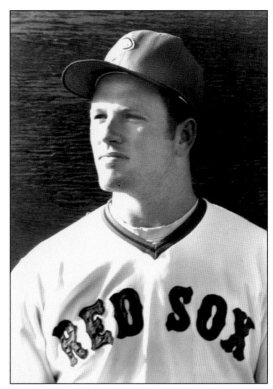

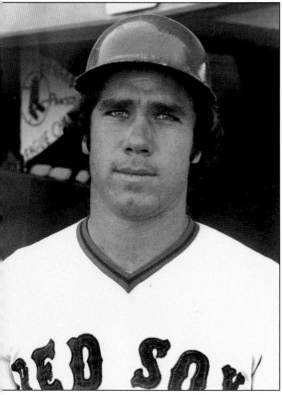

Gary "Muggsy" Allenson had a monster year for the PawSox in 1978. The burly catcher hit .299 with 20 homers and 76 RBIs and was named the International League's MVP. Allenson was also named to the International League All-Star team, along with teammates John LaRose and Dave Coleman. He became Carlton Fisk's backup in Boston in 1979 and remained with the Sox for six seasons. (Courtesy Pawtucket Red Sox.)

Cumberland, Rhode Island product John LaRose was an International League All-Star in 1978 after notching 15 saves to go with a 1.60 ERA. LaRose played with the PawSox for two seasons but saw just two innings of action with Boston. (Courtesy Pawtucket Red Sox.)

PawSox owner Ben Mondor was named the International League's Executive of the Year in 1978 after Pawtucket finished in second place (81-59), qualified for the playoffs for the second straight year, and saw its attendance figure jump from 70,354 to 112,267. (Courtesy *Pawtucket Times*.)

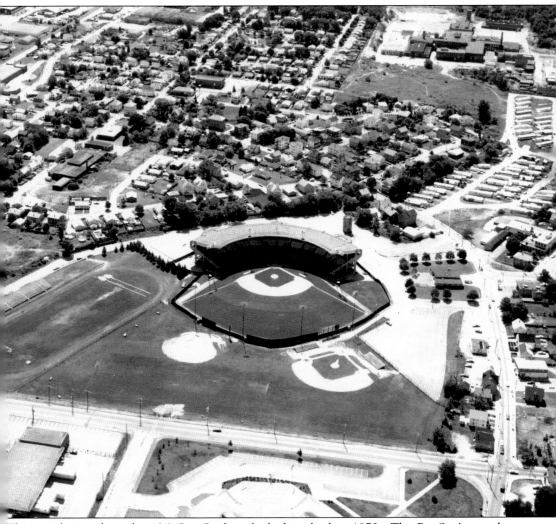

This aerial view shows how McCoy Stadium looked in the late 1970s. The PawSox' annual attendance figure increased in each of the first six years of Ben Mondor's ownership. McCoy hosted the International League All-Star Game in 1977 and exhibition games against the parent Boston Red Sox in 1977 and 1978, then again throughout the 1980s and 1990s. (Courtesy Pawtucket Red Sox.)

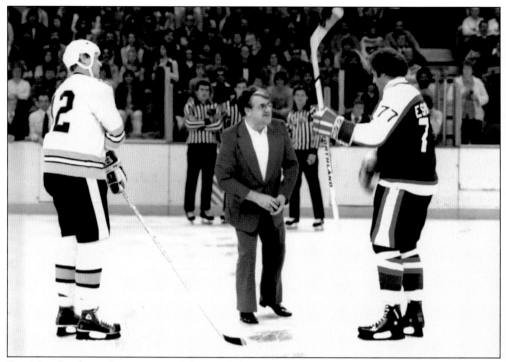

Ben Mondor drops the ceremonial first puck between Wayne Cashman (left) and Phil Esposito prior to a Boston Bruins–New York Rangers exhibition hockey game at the Providence Civic Center in the late 1970s. (Courtesy Pawtucket Red Sox.)

Garry Hancock pulls up safely into second base with a double. Hancock led the PawSox in hitting in 1978 (.303) and again in 1979, when his .325 average led the International League. He was an International League All-Star outfielder in 1982 and a functional utility player for both the Red Sox and Oakland for six seasons. (Courtesy *Pawtucket Times*.)

The PawSox had their third MVP in as many years when Dave Stapleton shared the award in 1979. Stapleton hit .306 while leading the International League in hits (169, still a PawSox record), doubles (33), runs scored (88), and total bases (249, tying Jim Rice's record). He became a valuable utility man for Boston over the next five seasons. In fact, had he been playing first base in game six of the 1986 World Series instead of Bill Buckner. . . . (Courtesy Pawtucket Red Sox.)

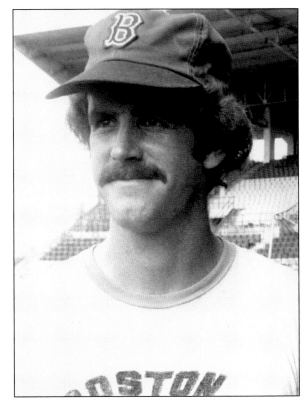

John Tudor's PawSox career started back in 1977, but his best season was 1979, when he went 10-11 with a 2.93 ERA. By the following season, he was a regular in Boston's starting rotation. In 1985, Tudor went 21-5 for the St. Louis Cardinals and wound up with a 117-72 record over 12 years with four different big-league clubs. (Courtesy Pawtucket Red Sox.)

Glenn Hoffman was an All-Star shortstop for the PawSox in 1979, his second full season with the club. Hoffman hit .285 that year and was known for both his solid defense and his rambunctious younger brother, Trevor, who used to hang around the team's clubhouse all the time. Trevor Hoffman was one of the premier closers in the game with the San Diego Padres by the late 1990s. (Courtesy Pawtucket Red Sox.)

Reid Nichols led the PawSox with 23 stolen bases in 1980. Over the next four and a half seasons, he was a key role player for Boston before being traded to the White Sox in 1985. (Courtesy Pawtucket Red Sox.)

Two PawSox pitchers who went on to great success in the big leagues later in the decade, Bruce Hurst (left) and Bobby Ojeda (middle), sit with PawSox pitching coach Mike Roarke prior to a game in 1980. (R.E.S., courtesy Pawtucket Red Sox.)

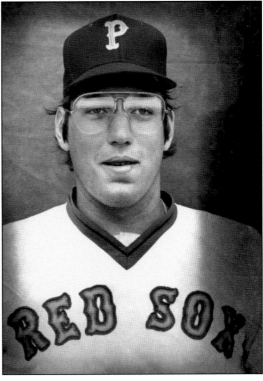

Rich Gedman spent most of the 1980 season with the PawSox, hitting .236 with 11 homers. The Worcester, Massachusetts native soon emerged as one of the better catchers in the American League. Gedman went up to Boston early in 1981, hit .288, and earned the *Sporting News'* American League Rookie of the Year award. He spent 11 seasons in Boston and 13 seasons in the big leagues. (Courtesy Pawtucket Red Sox.)

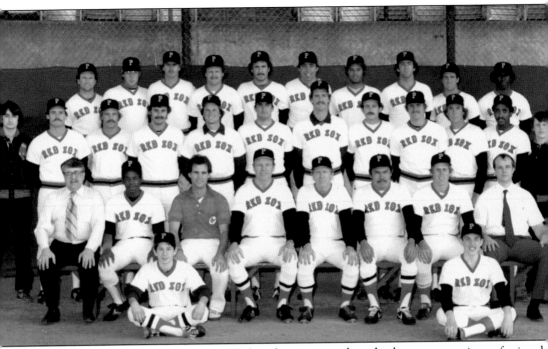

The 1981 PawSox only went 67-73, but they competed in the longest game in professional history that season, a 33-inning affair with the Rochester Red Wings. The members of the team in this photograph are, from left to right, as follows: (front row) owner Ben Mondor, Lee Graham, bat boy Kevin Broadbent, trainer Dale Robertson, pitching coach Mike Roarke, manager Joe Morgan, Luis Aponte, Russ Quetti, bat boy Billy Broadbent, and general manager Mike Tamburro; (middle row) clubhouse attendant Tony Varone, Wade Boggs, Dave Koza, Russ Laribee, Joel Finch, Bruce Hurst, Mike Smithson, Mike Howard, Keith MacWorther, Jim Dorsey, Julio Valdez, Mike Kinch, and public relations director Lou Schwechheimer; (back row) Sam Bowen, Rich Gedman, Win Remmerswaal, Danny Parks, Bob Ojeda, Roger LaFrancois, Manny Sarmiento, Mike Ongarto, Marty Barrett, and Chico Walker. (Courtesy Pawtucket Red Sox.)

The Longest Game began on Easter Eve, April 18, 1981. The PawSox and Red Wings played 32 innings that night and well into Easter Sunday before international League commissioner Harold Cooper finally ordered the game to stop at 4:09 a.m. By that time, PawSox skipper Joe Morgan had long been bounced from the game. He was ejected in the 22nd inning and watched the remainder of the game from a small hole cut out behind the backstop. (Courtesy Pawtucket Red Sox.)

When the Longest Game was resumed on June 23, major-league players were on strike, so the PawSox and Red Wings were the talk of the sports world. A throng of 5,765 fans jammed McCoy (which seated less than 6,000 at the time), along with media types from all over the world. Here, PawSox owner Ben Mondor is surrounded by the media prior to the resumption of the game. (Courtesy Pawtucket Red Sox.)

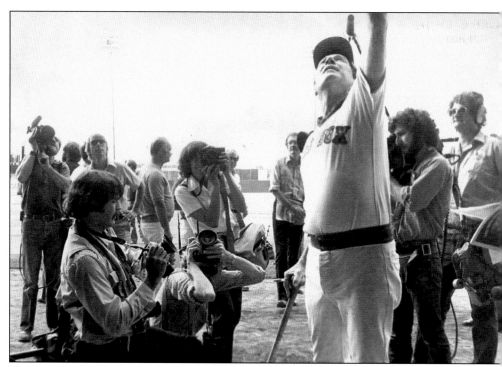

Photographers click away at Joe Morgan as he signs an autograph prior to the resumption of the Longest Game. The BBC and the Sunday *Mainichi* newspaper from Japan were among the press in attendance. (R.E.S., courtesy Pawtucket Red Sox.)

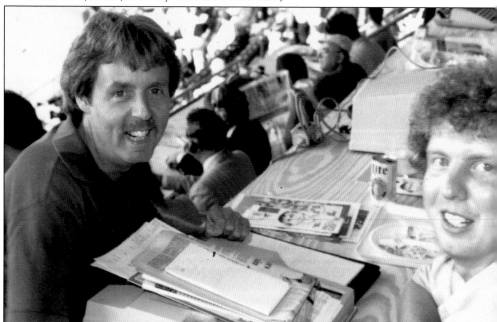

Boston Globe writers Peter Gammons (left) and Dan Shaugnessy took in the resumption of the Longest Game from the makeshift press area built behind the backstop specifically for this day. (Courtesy Pawtucket Red Sox.)

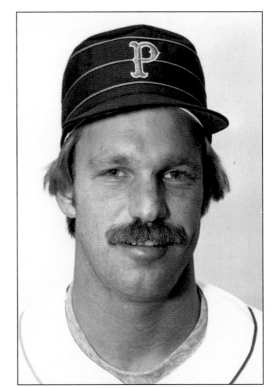

Dave Koza (right) never made it to "the show," but he is in the National Baseball Hall of Fame. A career minor-leaguer, Koza (below) follows through on the game-winning hit in the bottom of the 33rd inning to end the Longest Game. Koza's bat is enshrined at the hall of fame in Cooperstown, New York. Koza spent parts of seven seasons with the PawSox, a record matched only by Mike Rochford and Lou Merloni. (Courtesy *Pawtucket Times*.)

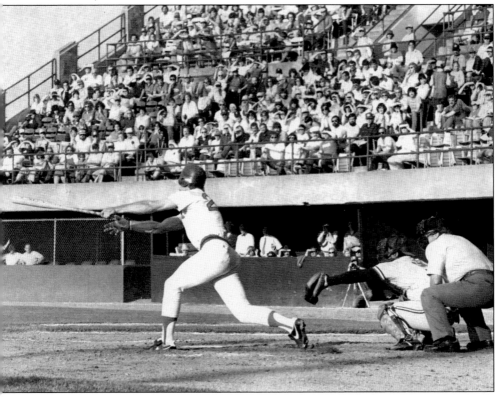

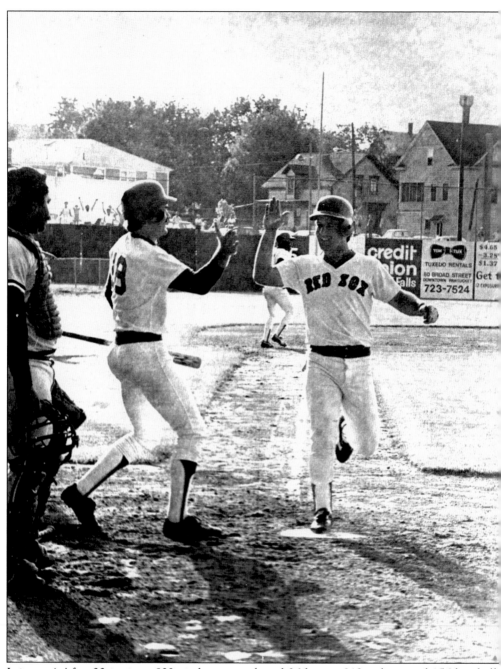

It is over! After 33 innings, 832 pitches, a combined 36 hits in 213 at-bats, and 156 baseballs used, the Longest Game finally came to an end when Marty Barrett scored from third base on Dave Koza's base hit. Barrett, who was hit by a pitch with one out in the bottom of the 33rd inning, is congratulated by on-deck hitter Wade Boggs as he crosses home plate with the winning run. Both Barrett and Boggs went on to become key members of the Red Sox. Barrett was a steady second baseman who was named the 1986 American League Championship Series MVP. He retired in 1991 after 10 big-league seasons, 9 with the Red Sox. (R.E.S., courtesy Pawtucket Red Sox.)

Seven of the eight PawSox pitchers who took the mound in the 33-inning marathon are (above, from left to right) Bobby Ojeda (who got the win), Bruce Hurst, Joel Finch, Mike Smithson, Manny Sarmiento, Luis Aponte, and Danny Parks. Win Remmerswaal (right) was the eighth pitcher. (Courtesy Pawtucket Red Sox.)

The Rochester Red Wings team that lost the Longest Game included a future Hall of Famer in their midst. Cal Ripken Jr. (back row, fifth from right, wearing uniform No. 5) was Rochester's starting third baseman in that game and, befitting his "Iron Man" reputation, played all 33 innings, going 2 for 13 and setting a professional baseball record with 15 plate appearances. Ripken, of course, went on to play a record 2,632 consecutive games from 1983 to 1999 with Baltimore and retired in 2001. (Courtesy Pawtucket Red Sox.)

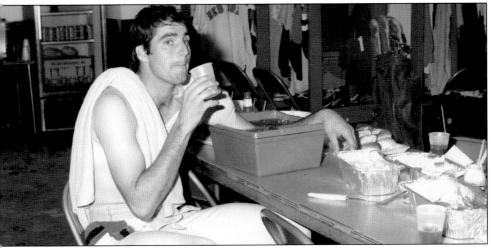

ruce Hurst, here icing down his arm, had a terrific season for the PawSox in 1981, going 2-7 with a 2.87 ERA and three shutouts. Hurst soon emerged as one of the top left-handed itchers in the majors. He won 10 or more games in 10 straight years with Boston (1983–1988) nd San Diego Padres (1989–1992). Hurst's best year in Boston was also his last, 1988, when e won a career-high 18 games to lead the Sox to the American League East title. (Courtesy awtucket Red Sox.)

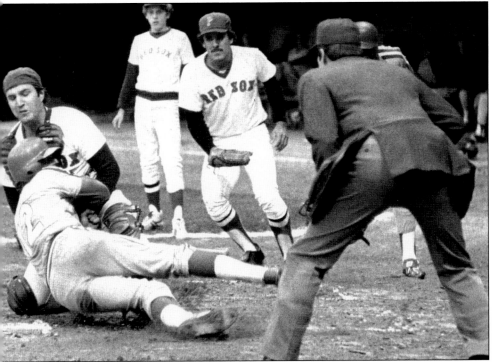

obby Ojeda (center, shown here backing up a play at home plate) was Pawtucket's ace pitcher 1 1981. He went 12-9 with a league-leading 2.19 ERA and was named the International eague's Most Valuable Pitcher. After four seasons in Boston, he signed with the New York fets in 1986 and was the ace of the staff (18-5, 2.57 ERA) for the team that beat the Red Sox 1 the World Series. (Courtesy Pawtucket Red Sox.)

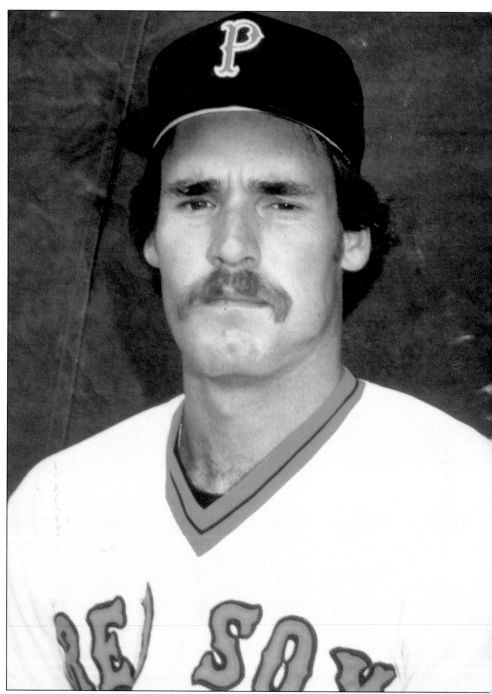

With a .335 average, Wade Boggs was the International League's leading hitter in 1981, h
second and final season with the PawSox. Boggs went on to become one of the greatest hitte
in Red Sox (and baseball) history: five batting titles (all with the Red Sox), 12 All-Star Gam
appearances, 3,010 career hits, a .328 career batting average, and a virtual lock to be electe
into the National Baseball Hall of Fame. His one World Series title, however, came in 199
with the New York Yankees. (J.M., courtesy Greg Murphy.)

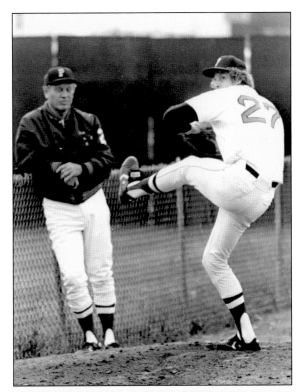

Mark Fidrych, one of the most unique players ever to put on a baseball uniform, spent two seasons with the PawSox (1982 and 1983). Fidrych (right, under the watchful eye of PawSox pitching coach Mike Roarke) took the baseball world by storm as a rookie with the Detroit Tigers in 1976. "The Bird" went 19-9 and won the American League Rookie of the Year award, and his face graced the cover of magazines everywhere thanks to his quirky personality traits like talking to the ball and manicuring the mound (below). (Courtesy Pawtucket Red Sox.)

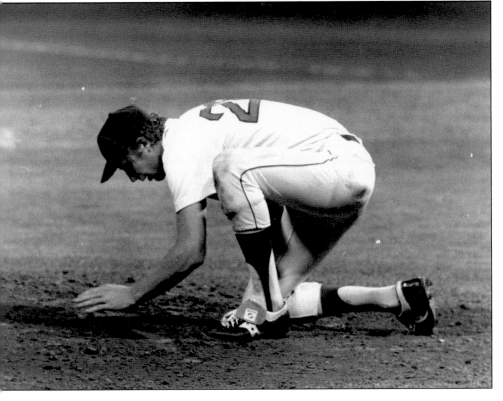

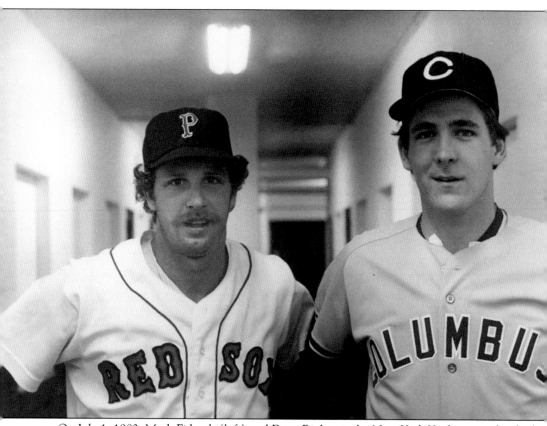

On July 1, 1982, Mark Fidrych (left) and Dave Righetti, the New York Yankees ace, hooked u in a game at McCoy Stadium between the PawSox and Columbus Clippers. The game drew McCoy Stadium record crowd of 9,389 fans. (R.E.S., courtesy Pawtucket Red Sox.)

One of the most popular players ever to don a PawSox uniform was Chico Walker. The second baseman was a fixture in Pawtucket for five seasons (1980–1984) and led the team with 58 RBIs in 1981 and with 18 homers and 42 stolen bases in 1984. However, he saw precious little time with Boston during that span—32 games, to be exact. His best major-league season came in 1991, when he hit .257 in 124 games with the Chicago Cubs. (Courtesy *Pawtucket Times*.)

Julio Valdez was another PawSox fan favorite in the early 1980s. The slick-fielding shortstop was with the team from 1979 to 1981, then again in 1984. (Courtesy Pawtucket Red Sox.)

After nine years at the helm, Joe Morgan left his job as PawSox manager following the 1982 season to become a scout for Boston. In 1985, he joined John McNamara's staff as Boston's first base coach, and on July 14, 1988, "Morgan's Magic" was officially born. Morgan replaced McNamara as manager on that date, and the Sox immediately won 12 straight and 19 of their next 20 games. Boston won the American League East title that season and again in 1990 under Morgan. (Courtesy Pawtucket Red Sox.)

Tony Torchia, who played on the PawSox' Junior World Series championship team in 1973, brought his winning ways back to Pawtucket as the team's manager a decade later. Torchia guided the PawSox to a worst-to-first finish in his two years at the helm, from last place in 1983 to a Governor's Cup championship in 1984. Torchia was named the International League's Manager of the Year that year. (Courtesy Pawtucket Red Sox.)

Dennis "Oil Can" Boyd (right) was one of the most memorable pitchers in PawSox and Red Sox history. Armed with a great nickname and a quirky nature, Boyd (below, delivering a pitch) spent most of the 1983 season in Pawtucket, racking up a team-high 129 strikeouts, before becoming a regular on the Red Sox staff over the next five seasons. His best year was in 1986, when Boyd helped lead Boston to the World Series with a 16-10 record and a 3.78 ERA. (Courtesy Pawtucket Red Sox.)

Shortstop Jackie Gutierez hit .266 for the PawSox in 1983 and earned a late-season promotion to Boston. (Courtesy Pawtucket Red Sox.)

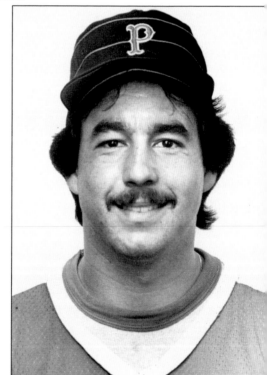

Al Nipper spent one season with the PawSox, going 9-4 in 1983. He was one of the top starters for the Red Sox over the next four seasons. (Courtesy Pawtucket Red Sox.)

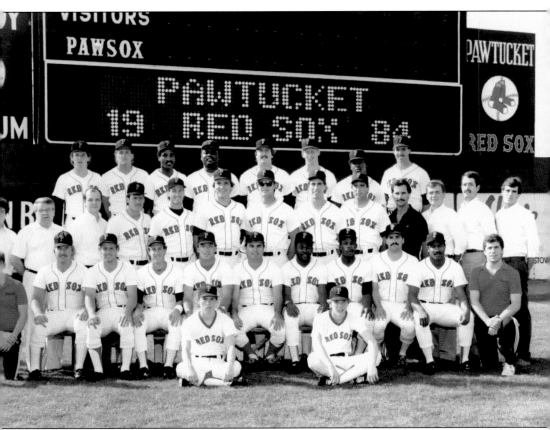

The PawSox won the International League's Governor's Cup in 1984. Pictured in this team photograph are, from left to right, the following: (front row) clubhouse attendant Billy Broadbent, Dave Malpeso, John Lickert, Paul Hundhammer, Kevin Romine, manager Tony Torchia, Gus Burgess, Lee Graham, Dennis Burtt, Juan Pautt, and clubhouse attendant Mick Tedesco; (middle row) Bill Corwin, owner Ben Mondor, general manager Mike Tamburro, George Mecerod, Steve Lyons, Marc Sullivan, Pat Dodson, Mike Rochford, Mike Brown, trainer Dale Robertson, assistant general manager Lou Schwechheimer, unidentified, and unidentified; (back row) Mike Davis, Paul Gnacinski, Julio Valdez, Reggie Whittemore, Robin Fuson, Tom Bolton, Chico Walker, and Kevin Kane. (Courtesy Pawtucket Red Sox.)

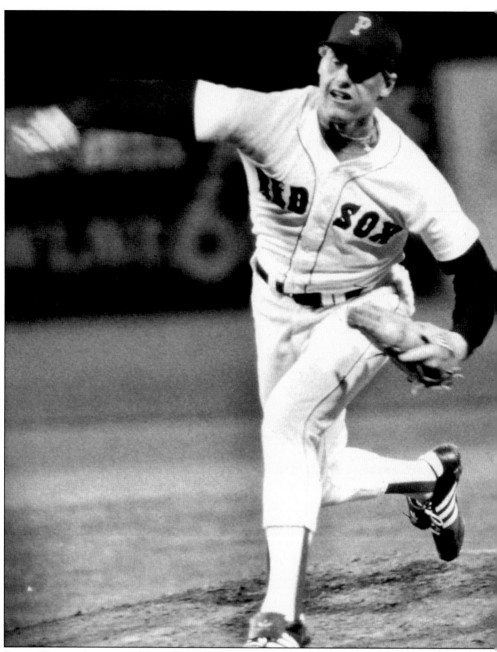

Roger Clemens's mercurial rise through the Red Sox farm system featured just a brief, seven start stint with the PawSox in 1984. He went 2-3 with a 1.93 ERA and 50 strikeouts in 46²/ innings, displaying the type of stuff that would make him one of the greatest pitchers in baseball history. Clemens struck out 20 batters in a game for Boston in 1986, went 24-4, and won the first of his six Cy Young Awards, along with the American League MVP award. In 1997, Clemens left the Red Sox for the Toronto Blue Jays, where he rejuvenated his career and won his fifth Cy Young. Two years later, the future Hall of Famer was traded to the New York Yankees, with whom he won his sixth Cy Young in 2001 and two World Series rings in 1999 and 2000. (Courtesy Pawtucket Red Sox.)

Kevin Romine led the PawSox with 72 RBIs in 1984. The outfielder spent parts of the next four seasons in Pawtucket while also serving as a valuable role player on Boston's 1988 and 1990 American League East Division championship teams. (Courtesy Pawtucket Red Sox.)

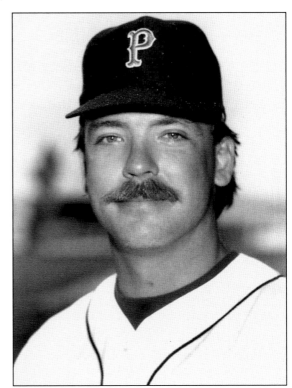

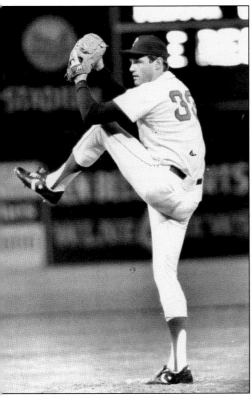

Rich Gale won 13 games with the Kansas City Royals in 1980. Four years later, he was with the PawSox. (Courtesy Pawtucket Red Sox.)

Steve Lyons (left) was the International League All-Star third baseman in 1984, when he hit .268 with 17 homers. He also hit a solo homer in the third inning of the decisive game of the Governor's Cup championship to break a scoreless tie and send the PawSox on to a 3-0 victory. Lyons (below, being congratulated after hitting a home run in April 1984) went on to a successful nine-year big-league career as a utility man, including four different stints with Boston (an unofficial record) and two more with the PawSox. (R.E.S., courtesy Pawtucket Red Sox.)

After the PawSox defeated the Maine Guides in the final game of the Governor's Cup championship, the Guides' owner, Jordan Kobritz (far right, with microphone), congratulates the champs (from left to right), Steve Lyons, Ben Mondor, Dave Malpeso, Mike Rochford, Gus Burgess, Pat Dodson, trainer Dale Robertson, Robin Fuson, manager Tony Torchia, Chico Walker, and Mike Tamburro. (Courtesy Pawtucket Red Sox.)

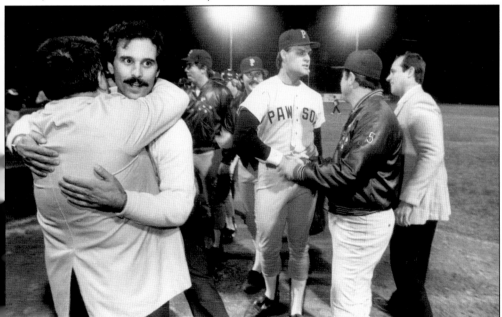

PawSox owner Ben Mondor (back to camera) hugs team trainer Dale Robertson after Pawtucket won its first and only Governor's Cup championship. At right, first baseman Pat Dodson shakes hands with manager Tony Torchia. Mike Tamburro is on the far right. (Courtesy Pawtucket Red Sox.)

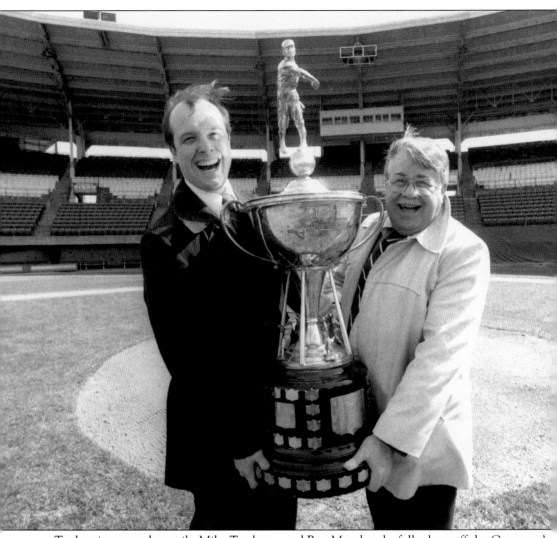

To the victors go the spoils. Mike Tamburro and Ben Mondor gleefully show off the Governor's Cup trophy the team brought back to Pawtucket after beating the Maine Guides in five games. While a World Series ring has painfully evaded their parent club for nearly a century, the 1984 PawSox were International League champions. After dropping the first two games of the best-of-five title series at home, the PawSox were forced to go up to the Ballpark in Old Orchard Park, Maine, and sweep three straight games to win the title. They did exactly that. (Courtesy Pawtucket Red Sox.)

Rac Slider, the longtime skipper for Single-A Winter Haven, took over the PawSox job for the 1985 season. Pawtucket went 48-91 that season, and Slider was replaced the following year by Ed Nottle. Slider remained in the Sox organization for several years and was Boston's third base coach in the late 1980s. (Courtesy Pawtucket Red Sox.)

Ed Nottle replaced Rac Slider as PawSox manager in 1986. An outgoing, jovial type, Nottle was named the International League's Manager of the Year in 1987 after leading the PawSox to a 73-67 record, despite having 13 different players called up to Boston. Nottle posted the second-most wins in PawSox managerial history (302) before being let go midway through the 1990 season. (Courtesy Pawtucket Red Sox.)

Mike Greenwell (left) had two successful seasons in Pawtucket before embarking on an impressive career in Boston. Greenwell (below, making a running catch) led the PawSox in hitting (.256) and RBIs (56) in 1985 and then hit .300 in 1986 before being called up to the parent club in late July. In 1988, Greenwell finished second to Jose Canseco in the American League MVP voting after hitting .325 with 22 homers and 119 RBIs. He retired after the 1996 season with a .303 career average. (Courtesy Pawtucket Red Sox.)

am Horn made his first trip to
awtucket in 1986. He hit just .196
ith three homers in 20 games. The
Illowing season, he emerged as one of
ie greatest power hitters in PawSox
istory. (Courtesy Pawtucket Red Sox.)

LaSchelle Tarver led the PawSox with a
.320 batting average and 31 stolen bases
in 1986, earning him a brief call-up to
Boston at the season's end. (Courtesy
Pawtucket Red Sox.)

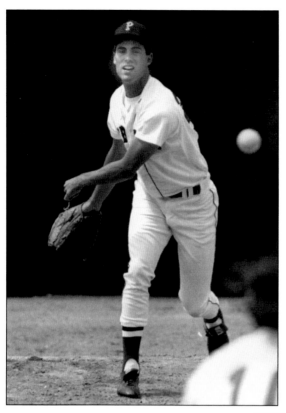

Perhaps the best of Mike Rochford's seven seasons with the PawSox came in 1986, when he led the club with 11 wins. Rochford, who had a team-best 2.37 ERA in 1989, was a PawSox pitcher from 1984 to 1990 and is one of only three players in club history to play in parts of seven straight seasons with the team. Dave Koza (1977–1983) and Lou Merloni (1996–2002) are the others. (Courtesy Pawtucket Times.)

Pat Dodson had one of the greatest offensive seasons in PawSox history in 1986. The big first baseman led Pawtucket with 27 homers and 102 RBIs (a club record) and earned the International League's MVP and Star of Star awards. (Courtesy Pawtucket Red Sox.)

John Marzano spent the first of parts of five different seasons with the PawSox in 1987. A top-notch catching prospect and Boston's No. 1 pick in the 1984 draft, Marzano played in Pawtucket from 1987 to 1989, as well as in 1990 and 1992. He contributed as a back-up catcher in Boston during that span as well. (Courtesy Pawtucket Times.)

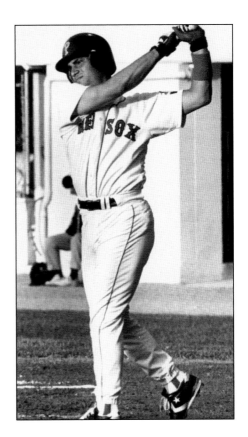

Steve Curry was a career minor-leaguer who earned exactly three major-league starts. He made history with the PawSox on July 6, 1987, when he fired a no-hitter in Pawtucket's 11-0 win at Richmond. It was just the fifth no-hitter in club history and just the second nine-inning game with no hits and no runs, as well as the first nine-inning no-hitter in the International League in over 10 years. (Courtesy Pawtucket Red Sox.)

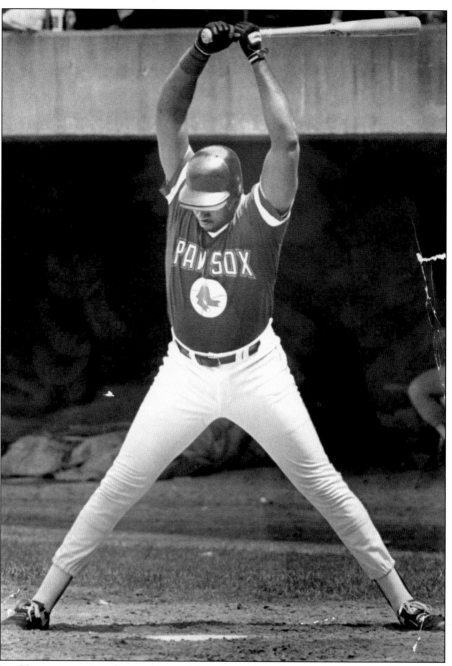

Big Sam Horn was a minor-league homer-hitting machine who was never quite able to duplicate that success in the majors. Horn (jackknifing out of the way of an inside pitch) had a huge season in 1987, clubbing 30 homers and also leading Pawtucket in hitting (.321) and RBIs (84). He hit 14 homers in just 46 games with Boston that year but was never really a factor with the Red Sox over the next two seasons. Horn had his best major-league season in 1991 with Baltimore (23 home runs), but his greatest successes still came in the minors. In 1993, Horn set an International League record with 38 homers for the Charlotte Knights (that record was broken three years later by Toledo's Phil Hiatt, who hit 42). (R.D., courtesy *Pawtucket Times*.)

ody Reed spent part of 1986 and all of
987 with the PawSox. He hit .296 in 136
ames in 1987 and was Boston's starting
hortstop the following season. Reed was a
onsistent player for the Red Sox for five
easons. (Courtesy Pawtucket Red Sox.)

oung fans seek autographs from PawSox players prior to a game on August 29, 1987. (J.S.,
ourtesy *Pawtucket Times*.)

Brady Anderson (left) spent parts of two seasons with the PawSox. Anderson (below, ripping into a pitch) hit .380 with Pawtucket in 1987, but on July 29, 1988, he and a young pitcher named Curt Schilling were sent to Baltimore in exchange for Mike Boddicker. Boddicker helped pitch the Boston Red Sox to pennants in 1988 and 1990. Anderson hit 50 home runs for the Orioles in 1996 whil Schilling led the Arizona Diamondbacks to the 2001 World Series title. (R.D., courtesy Pawtucket Red Sox.)

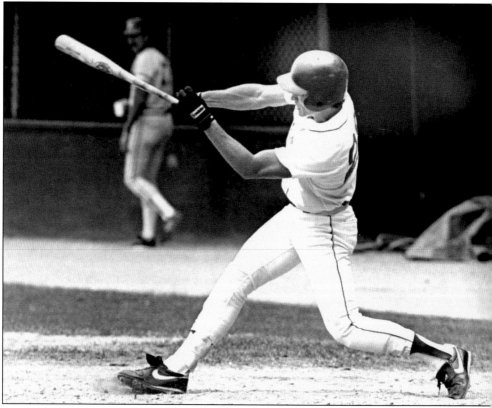

Carlos Quintana unwinds some bubble gum in the PawSox dugout in August 1988. The Venezuelan native led Pawtucket that year with a .285 average, 16 homers, 66 RBIs, and was the team's lone All-Star. Quintana led Pawtucket in hitting again in 1989 (.287). Once, he left McCoy Stadium in the first inning of a doubleheader, drove up to Boston, and reached Fenway Park in time to start in the outfield for the Red Sox. (J.S., courtesy *Pawtucket Times*.)

PawSox president Mike Tamburro was named the International League's Executive of the Year for the second time in 1988. Tamburro was general manager of the PawSox from 1977 to 1984 and was named the International League Executive of the Year following the PawSox' Governor's Cup championship season. In January 1986, Tamburro was named the team president, a title he has held ever since. (Courtesy Pawtucket Red Sox.)

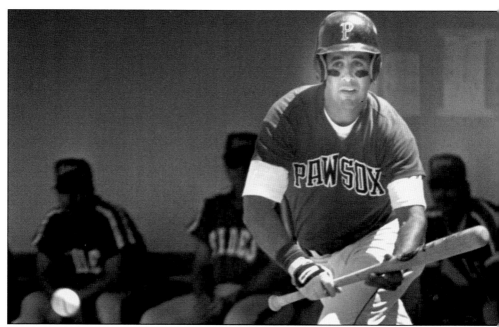

Rick Lancellotti was a real-life version of Crash Davis, a career minor-leaguer who traveled the long, hard road through minor-league towns for many years. Born in Providence, Rhode Island, Lancellotti began his professional baseball career in 1977 with Charleston of the Carolina League and eventually went all over the country, even to Hawaii. Lancellotti landed in Pawtucket in 1989 at the age of 31 and hit a team-high 17 homers. (R.D., courtesy *Pawtucket Times*.)

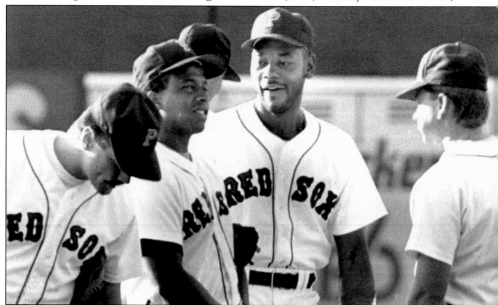

Ellis Burks (second from right) nearly bypassed Pawtucket altogether. After two strong seasons with Double-A New Britain, he played just 11 games for the PawSox before being promoted to Boston in 1987 and posting a tremendous rookie season (.272, 20 homers). This picture was taken during a five-game rehab stint in 1989, but otherwise he has been a major-leaguer ever since. He hit 28 homers in 2001 at the age of 36 with Cleveland. (R.D., courtesy *Pawtucket Times*.)

A recurring blood clot in his right shoulder forced Oil Can Boyd onto the disabled list five times from 1987 to 1989, and he made several rehab appearances with the PawSox during that time. After the 1989 season, he signed with the Montreal Expos as a free agent. His big-league career was over two years later. (W.H., courtesy Pawtucket Red Sox.)

Tim Naehring's future looked as bright as his megawatt smile after he hit 15 homers with the PawSox and was the International League's All-Star shortstop in 1990. But injuries sidetracked Naehring throughout his career, and he never became the player the Sox originally hoped he would become. (R.B., courtesy *Pawtucket Times*.)

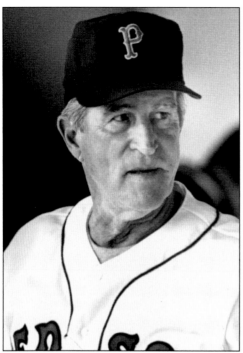

Red Sox legend Johnny Pesky took over as PawSox manager on June 27, 1990, after Ed Nottle was fired. The PawSox went 32-41 to close out the season under Pesky, and he was replaced the next season by Butch Hobson. (R.D., courtesy *Pawtucket Times*.)

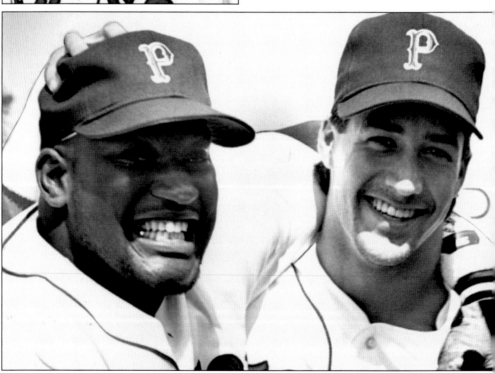

Like Jim Rice and Fred Lynn some 25 years earlier, Mo Vaughn (left) and Phil Plantier were the "Gold Dust Twins, Part II," for the PawSox in 1990. Both put up big numbers that season and went on to meet with success in the major leagues in the near future. (R.D., courtesy *Pawtucket Times*.)

Phil Plantier connects with a pitch (right), and crosses home plate (below) after belting one of his International League-leading 33 home runs in 1990, still the second-highest single-season total in franchise history. The slugging outfielder earned International League Rookie of the Year and All-Star honors that year. (R.D., courtesy *Pawtucket Times*.)

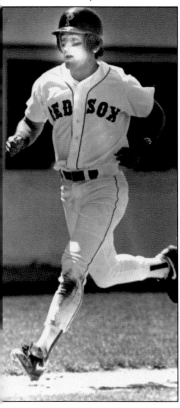

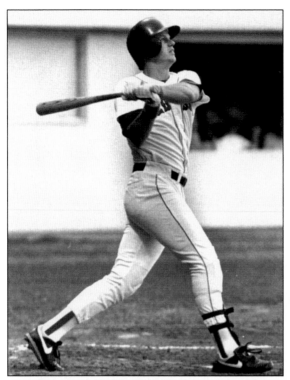

Scott Cooper (left) hit .266 with 12 home runs in 1990, the first of his two productive seasons with the PawSox. The following year, Cooper (below, being congratulated by teammates after hitting a home run) was the PawSox' MVP and the International League All-Star third baseman after hitting .277 (second in the league) with 15 homers and 72 RBIs. (R.B., courtesy *Pawtucket Times*.)

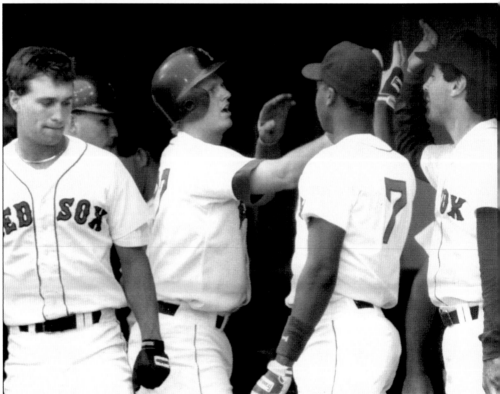

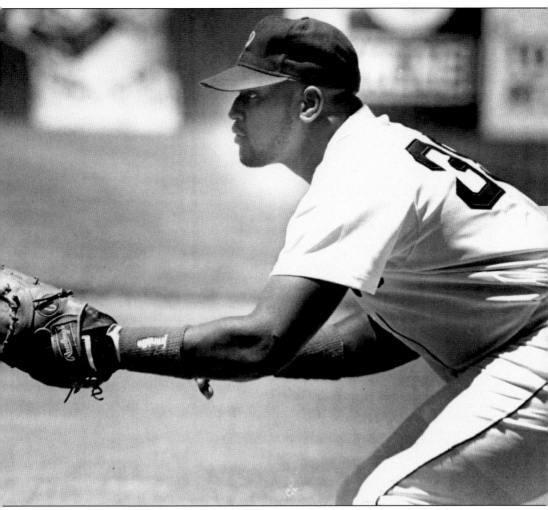

Mo Vaughn was one of the most popular players in PawSox (and Red Sox) history. Vaughn caught fire in the second half of the 1990 PawSox season and wound up hitting .295 with 22 home runs and 72 RBIs. The big first baseman was named the PawSox' MVP and, after splitting the next two seasons between Pawtucket and Boston, soon blossomed into one of the most feared hitters in the majors. He earned American League MVP honors in 1995 (.300, 39 homers, 126 RBIs) and guided the Red Sox to a pair of postseason appearances before leaving the team for the Anaheim Angels via free agency after the 1998 season. After three injury-plagued years in Anaheim, he signed with the New York Mets in 2002. (R.D., courtesy Pawtucket Times.)

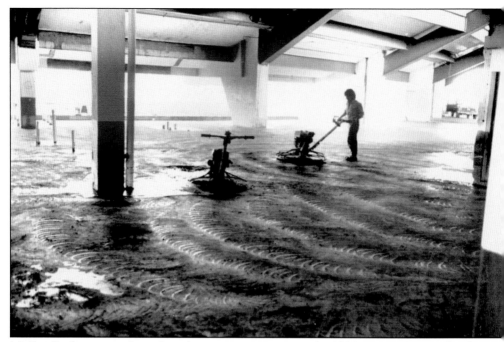

McCoy Stadium went through its first renovation prior to the 1991 season. Among the change were improvements to the clubhouses. Players were soon able to enter their respective clubhouse through their dugout, rather than through the same door located behind the backstop. (R.B. courtesy *Pawtucket Times*.)

Butch Hobson (right) was named the PawSox' seventh manager in 1991, and his success was immediate. Hobson guided Pawtucket to the International League Eastern Division title with a 79-64 record and earned Manager of the Year honors from both the International League and *Baseball America*. Hobson was a fiery competitor whose style could be confrontational (below). He was promoted to manage Boston the very next year and held that position for three seasons. (Courtesy *Pawtucket Times*.)

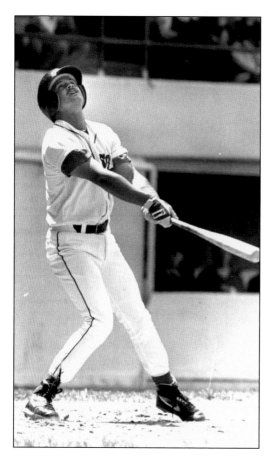

John Valentin was Mo Vaughn's teammate in college at Seton Hall, then with the PawSox, Red Sox, and, eventually, the New York Mets. His first season with the PawSox was 1991, when he hit .264 with nine homers in 100 games. (K.L., courtesy *Pawtucket Times*.)

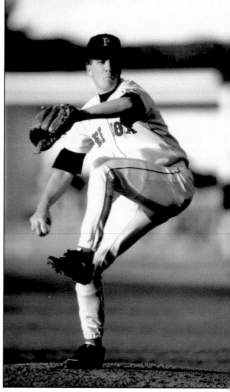

Canadian-born pitcher Paul Quantrill won a team-high 10 games for Pawtucket in 1991. He was traded from Boston to Philadelphia in 1994 and has since emerged as a top middle reliever. In 2001 with Toronto, Quantrill went 11-2 and earned his first trip to the All-Star Game. He spent 2002 with the Los Angeles Dodgers. (Courtesy Pawtucket Red Sox.)

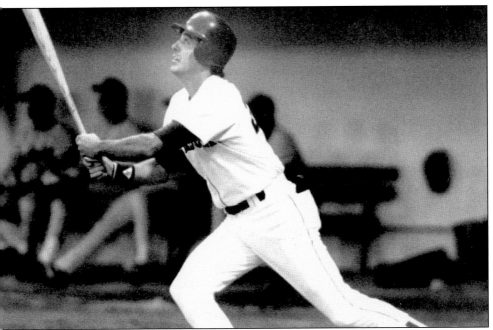

t the age of 34, Rick Lancellotti led the International League with 21 homers in 1991. Over professional career that began in 1977, Lancellotti's entire big-league career consisted of just rief cups of coffee with San Diego (1982), San Francisco (1986), and four games with Boston 1990. (R.D., courtesy *Pawtucket Times*.)

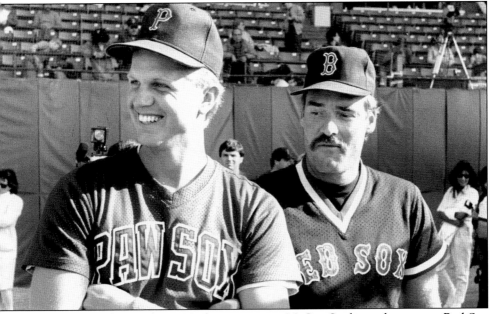

1 this photograph, taken at the 1990 alumni game at McCoy Stadium, the present Red Sox hird baseman, Wade Boggs, is looking over the shoulder of the future third baseman, Scott Cooper. After two strong seasons with Pawtucket, Cooper became Boston's regular third aseman upon Boggs's departure to the New York Yankees in 1992. Cooper was Boston's lone ll-Star Game representative in both 1993 and 1994. (R.B., courtesy *Pawtucket Times*.)

Syracuse's Rob Ducey barely beats the toss to first base to pitcher Josias Manzanillo in a 199 game. Later that year, Manzanillo embarked on a major-league career that has seen him spen time with six different teams as a reliever. He was with the Pittsburgh Pirates from 2000 1 2002. (R.B., courtesy *Pawtucket Times*.)

Phil Plantier was an International League All-Star again in 1991 after hitting a team-high .305. Plantier was traded to San Diego in December 1992 and had 34 homers and 100 RBIs for the Padres in 1993. Plantier's production petered out after that, and his career was over after the 1997 season. (R.D., courtesy *Pawtucket Times*.)

One of the few Pawtucket natives who actually got a chance to play with the PawSox was Ken Ryan (right). Born in Pawtucket and raised in Seekonk, Massachusetts, Ryan (below, obliging autograph seekers) was signed by the Red Sox in June 1986. He made his PawSox debut in 1991 and spent parts of four seasons with Pawtucket (1991–1992, 1993, and 1995) while also contributing in the Boston bullpen. After four years with Philadelphia, Ryan retired in July 2000. (Courtesy *Pawtucket Times*.)

Who is that masked man? It is Todd Pratt, who played for the PawSox for just one season (1991). He has since carved out a 10-year major-league catching career with the Phillies, Cubs and Mets. (R.B., courtesy *Pawtucket Times*.)

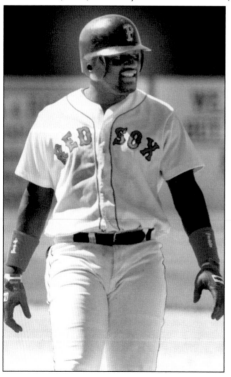

After getting off to a slow start (.185) in Boston, Mo Vaughn was sent back down to Pawtucket in May 1992. He hit .282 with six homers in 36 games with the PawSox before getting called back up on June 22. He has been one of the most feared sluggers in the big leagues ever since. (Courtesy *Pawtucket Times*.)

Rico Petrocelli hits some ground balls during infield practice. The former Red Sox star replaced Butch Hobson as the eighth manager in PawSox history for the 1992 season. Pawtucket went 71-72 under Petrocelli, and Buddy Bailey took over the spot the following season. (R.D., courtesy *Pawtucket Times*.)

Bob Zupcic looks up for the umpire's call after sliding into third base. Zupcic spent parts of four seasons (1989, 1991, 1992, and 1994) with Pawtucket. In 1992, he hit .276 in 124 games with Boston. (R.B., courtesy *Pawtucket Times*.)

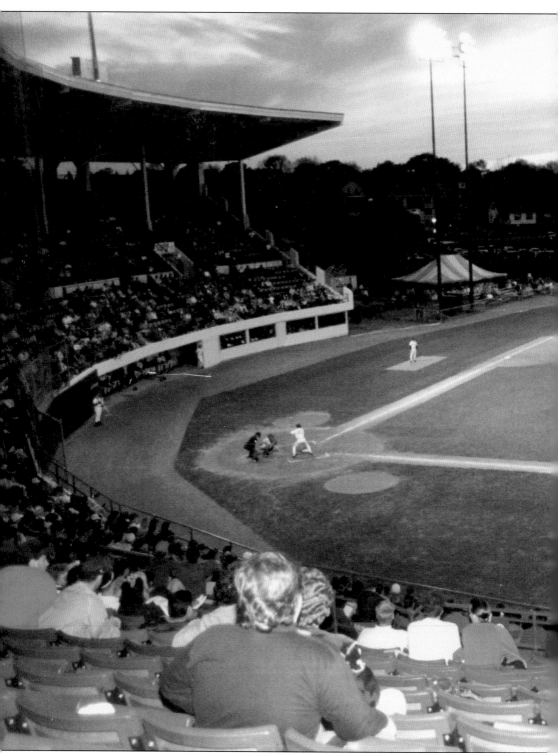

Day turns to evening on a summer night at McCoy Stadium in the mid-1990s. Just a few year
later, the McCoy renovation project transformed the ballpark into one of the very best venue.

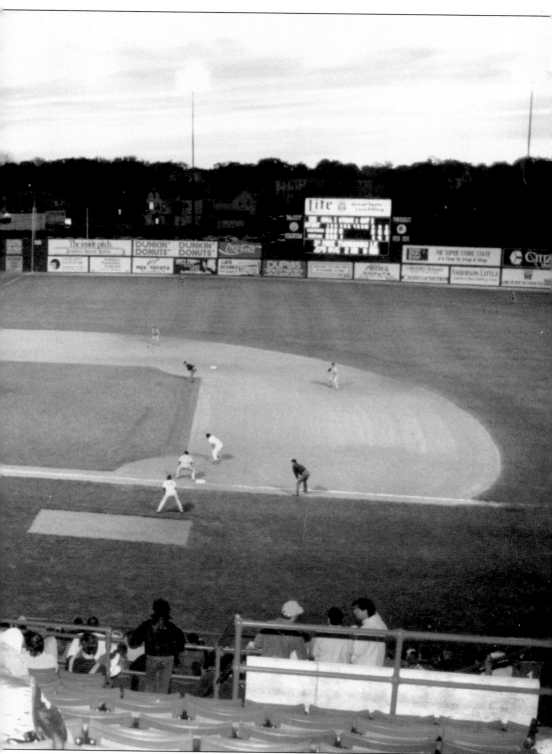

n all of Triple-A baseball. (Courtesy Pawtucket Red Sox.)

Does this PawSox second baseman have a familiar face? It is Tommy Barrett, Marty's younger brother. Tommy, here turning a double play while future star J.T. Snow of Columbus slides into second, did not have as distinguished a career as his brother. He played just 54 big-league games, only four of which came with Boston. (K.L., courtesy *Pawtucket Times*.)

Catcher John Flaherty, shown here trying to sweep a tag on Scranton's Ruben Amaro, played parts of four seasons with the PawSox (1990–1993). He has since played for the Detroit Tigers, San Diego Padres, and Tampa Bay Devil Rays, with whom he broke up Pedro Martinez's bid for a no-hitter in the ninth inning of a game in August 2000. (R.D., courtesy *Pawtucket Times*.)

A staple at McCoy for many years was the annual Red Sox Alumni Game, an exhibition game between the PawSox and their parent club. In the 1992 game, Boston outfielder (and former PawSox) Mike Greenwell is about to be tagged out by Pawtucket second baseman Tommy Barrett while trying to steal second. Eric Wedge made the throw. (R.B., courtesy *Pawtucket Times*.)

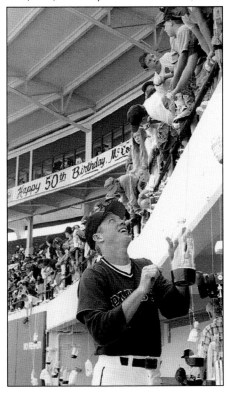

McCoy Stadium celebrated its 50th anniversary on July 1, 1992. Here, PawSox player Van Snider gladly signs autographs for fans. Later in the night, Snider hit a game-winning grand slam. (R.D., courtesy *Pawtucket Times*.)

John Valentin (here catching some serious hang time on a throw to second base) began the 1992 season with Pawtucket but was called up to Boston in July. He became Boston's regular shortstop until 1997, when he was moved over to third to make room for a young prospect named Nomar Garciaparra. Valentin was a leader on Boston's playoff teams of 1995, 1998, and 1999, but injuries hastened his release from the club. In 2002, he was a member of the Mets. (K.L., courtesy *Pawtucket Times*.)

PawSox vice president and general manager Lou Schwechheimer was festooned with awards following Pawtucket's 1992 season, earning Executive of the Year honors from both the International League (for the second time) and the *Sporting News*. Schwechheimer began his career with the PawSox as a college intern in 1979. He was the team's director of public relations from 1981 to 1983 and assistant general manager from 1984 to 1985 before being promoted. (Courtesy Pawtucket Red Sox.)

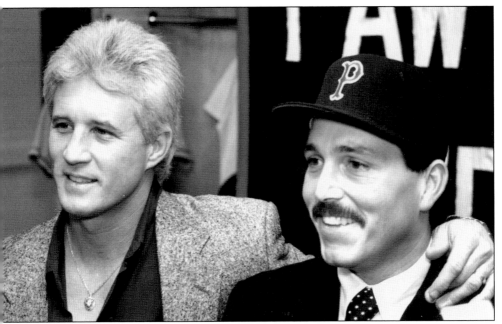

In 1993, Buddy Bailey became the PawSox' ninth (and, at age 35, youngest) manager in team history. Bailey (right) is shown here at his introductory press conference with Butch Hobson. He guided the PawSox to the International League East pennant in his second season at the helm after a 30-7 start, the best in the history of the International League. (R.D., courtesy *Pawtucket Times*.)

One of the true characters of the game, Steve "Psycho" Lyons made his third (and final) go-round with the PawSox in 1993. Lyons, the only player in Pawtucket Red Sox history to play all nine positions and designated hitter, showed off his versatility during a PawSox game by selling peanuts and popcorn and cooking pizza. (Courtesy Pawtucket Red Sox.)

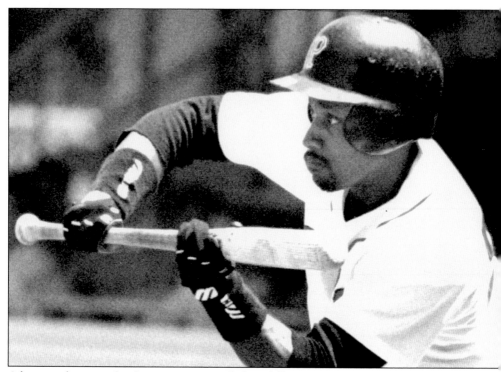

After spending nine big-league seasons with four different teams, Herm Winningham emerged in Pawtucket for the 1993 season. (R.D., courtesy Pawtucket Red Sox.)

Tim Naehring began the 1993 season on the disabled list with a right shoulder tear and did not start playing with the PawSox until July. Naehring hit .307 in 55 games with Pawtucket before being recalled to Boston on August 11. Injuries continued to plague him, however, and he retired from the game after the 1997 season. (R.D., courtesy *Pawtucket Times*.)

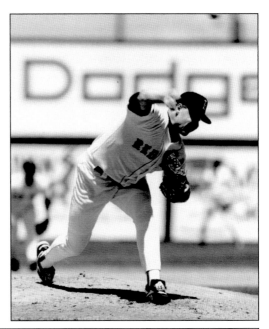

On July 11, 1993, Roger Clemens (right) returned to McCoy Stadium as a PawSox for the first time in over nine years for a rehab start. The six-time Cy Young Award winner (below, chatting with PawSox pitching coach Rick Wise prior to the game) dazzled the McCoy crowed by giving up one hit and striking out eight over three and two-thirds innings against the Richmond Braves. (Courtesy Pawtucket Red Sox.)

International League hitters feared this view in 1993. Aaron Sele was named the International League's Pitcher of the Year after going 8-2 with a 2.19 ERA. He was then promoted to Boston on June 22 and went 6-0 in his first eight starts. Sele spent five seasons with Boston but really blossomed after being traded to the Texas Rangers in 1998, winning a career-high 19 games that season. He was a key starter for the Anaheim Angels in 2002. (R.D., courtesy *Pawtucket Times*.)

This was a familiar site in 1993—Greg Blosser being congratulated after hitting a home run. Blosser clubbed a team-high 23 round-trippers in 1993 and had 17 more in 1994. (R.D., courtesy *Pawtucket Times*.)

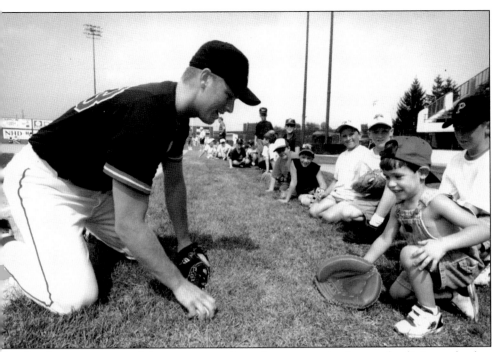

The PawSox are renowned for getting out into the community for youth clinics and other public appearances. Here, Scott Hatteberg offers some catching advice to a youngster at a PawSox Youth Clinic in 1994. Hatteberg emerged as a serviceable catcher for Boston and was traded to the Oakland Athletics after the 2001 season. (Courtesy *Pawtucket Times*.)

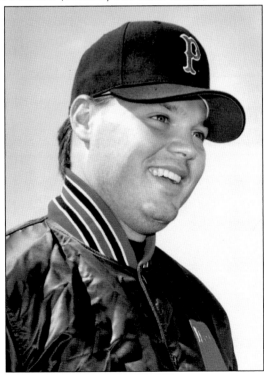

Reliever Cory Bailey appeared in 52 games for the PawSox in 1993 and 3 more the following season. He was a key component of the Kansas City Royals' bullpen in 2001 and 2002. (R.D., courtesy *Pawtucket Times*.)

Former Red Sox and PawSox great Jim Rice has been a frequent visitor to McCoy Stadium in recent years, as a roving minor-league hitting instructor (as in this 1994 photograph) and, currently, as one of the organization's special instructors. (L.M.Z., courtesy Pawtucket Red Sox.)

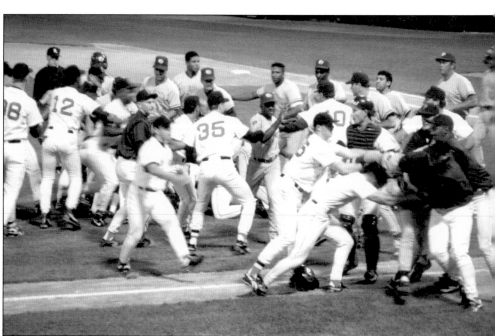

It is not always fun and games at McCoy Stadium, as this brawl between the PawSox and Syracuse Chiefs in 1994 indicates. (L.M.Z., courtesy Pawtucket Red Sox.)

Catcher Eric Wedge began his PawSox career in 1991. Two years later, he was the Colorado Rockies' second-round selection in the expansion draft. However, by 1994, he was back in Pawtucket. Wedge clubbed 9 homers for the PawSox in 1994 and 20 in 1995. He was the International League's Manager of the Year in 2001 after skippering the Buffalo Bisons to the playoffs. (Courtesy *Pawtucket Times*.)

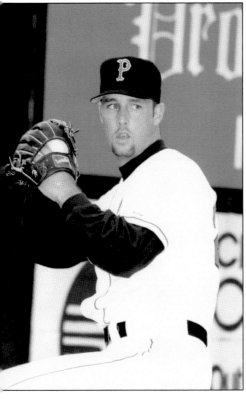

Knuckleballer Tim Wakefield was waived by Pittsburgh at the start of the 1995 season and picked up by the Red Sox. He made four starts with the PawSox (2-1, 2.52 ERA) before being promoted to Boston. There, he went 14-1 in his first 17 starts and wound up with the most wins for a pitcher for the American League East champions with a 16-8 record. He has been a valuable, versatile pitcher for the Sox ever since. (Courtesy Pawtucket Red Sox.)

99

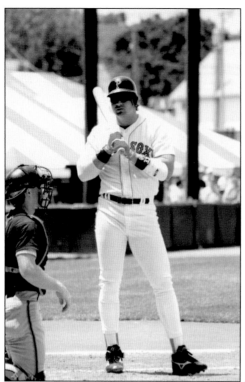

Red Sox slugger Jose Canseco (left) made brief rehab stints with the PawSox in both 1995 and 1996. Canseco (below, signing autographs) was the first 40-40 man in big-league history and the 1988 American League MVP while with Oakland. He retired in 200? with 462 career home runs. (L.M.Z., courtesy Pawtucket Red Sox.)

Roger Clemens made another rehab start with the PawSox on May 28, 1995. He gave up just one hit over five innings and returned to Boston the next day. Here, "the Rocket" is interviewed by "Psycho" (Steve Lyons, Clemens's former Red Sox and PawSox teammate) for ESPN2. (Courtesy Pawtucket Red Sox.)

Stout slugger Matt Stairs led Pawtucket with a .284 batting average and hit 13 homers in his one season with the PawSox in 1995. He clubbed 38 homers four years later for the Oakland Athletics. Stairs played for the Milwaukee Brewers in 2002. (L.M.Z., courtesy Pawtucket Red Sox.)

Nomar Garciaparra's stay in Pawtucket was brief but memorable. The Red Sox' top overall pick in the 1994 amateur draft, Garciaparra shot his way up through the organization's farm system in three short years. He joined the PawSox in 1996, at the age of 23, and despite a couple of trips to the disabled list, made an immediate impression. Garciaparra played just 43 games with Pawtucket but hit .343 with 16 homers and 46 RBIs. His home run total remains the highest ever for a PawSox shortstop, and he was voted the PawSox' Rookie of the Year by his teammates. Garciaparra was called up to Boston at the end of August, and the rest is history: American League Rookie of the Year in 1997, 35 home runs in 1998, American League batting titles in 1999 (.357) and 2000 (.372), and the unerring love of the Red Sox Nation. (B.J.G. courtesy Pawtucket Red Sox.)

"Looouuu!" has been a familiar chant at both McCoy Stadium and Fenway Park ever since 1996. Lou Merloni, one of the most popular players ever to don a PawSox (or Red Sox) uniform, began a long PawSox–Red Sox career that year. When the Framingham, Massachusetts native and Providence College graduate was sent from Boston to Pawtucket in 2002, he matched a dubious club record by playing parts of seven straight seasons with the club. (Courtesy Pawtucket Red Sox.)

Jeff Suppan led the PawSox with 10 wins and 146 strikeouts in 1996. He spent parts of three seasons (1995–1997) between Boston and Pawtucket and was a reliable starter for the Kansas City Royals in 2002. (Courtesy Pawtucket Red Sox.)

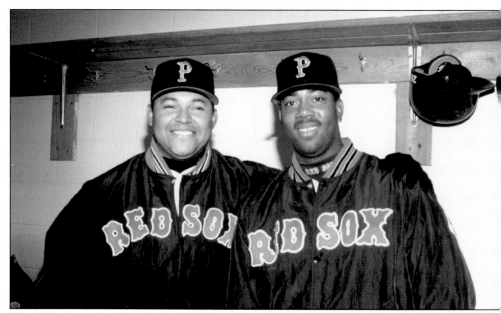

Two of the more popular players in PawSox lore, Rich Garces (left) and Pork Chop Pough, pose for a picture in 1996. Garces, the lovable "El Guapo," saw action in parts of four straight seasons with the PawSox (1996–1999) before developing into one of Boston's top bullpen men. Pough spent two seasons in Pawtucket (1995 and 1996) and still boasts one of the most recognizable names in franchise history. (Courtesy Pawtucket Red Sox.)

After guiding the PawSox to a first-place finish (78-64) and being named the International League's Manager of the Year in 1996, Buddy Bailey was promoted to major-league advance scout for the Red Sox. He held several other jobs in the organization (including bench coach in Boston in 2000) before being renamed PawSox manager in December 2001. (R.D., courtesy *Pawtucket Times*.)

On December 4, 1996, Ken Macha was named the 10th manager in PawSox history. Macha guided the PawSox to a franchise-record 81 wins in his debut season and a spot in the playoffs, where they lost to Rochester in the International League East Championship. In 1998, Macha was named the International League's Manager of the Year after leading the PawSox to a 77-64 mark. Macha left after that season to join the Oakland Athletics as a bench coach. (Courtesy Pawtucket Red Sox.)

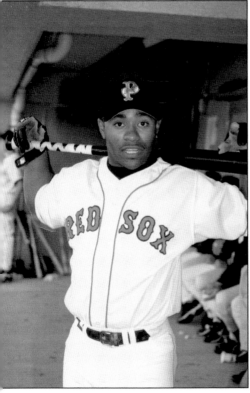

Donnie Sadler's up-and-down career with the PawSox began in 1997 and ended after the 2000 season. In between, there were plenty of call-ups to Boston—and eventual demotions back to Pawtucket. A gritty little player, he was traded to the Cincinnati Reds in 2001 and has since played for Kansas City and Texas. (Courtesy Pawtucket Red Sox.)

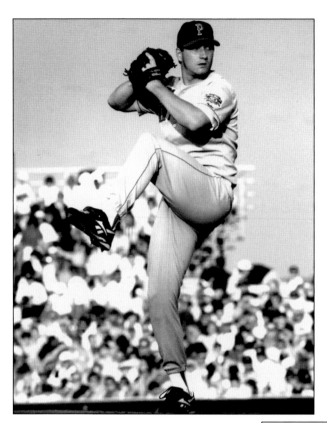

Local boy Brian Rose had one of the greatest seasons in PawSox pitching history in 1997. The South Dartmouth, Massachusetts native (shown here pitching in the 1997 Triple-A All-Star Game) went 17-5 and his win total set a PawSox franchise record and led all of minor-league baseball. He also led the International League with a 3.02 ERA and was named the International League's Most Valuable Pitcher and Rookie of the Year. (B.J.G., courtesy Pawtucket Red Sox.)

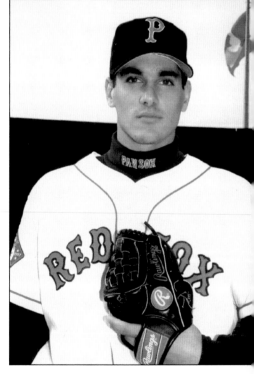

Along with Rose, Carl Pavano was another top-notch pitching prospect with the PawSox in 1997. He went 11-6 with a 3.12 ERA and led the team with 147 strikeouts. However, on November 18 of that year, Pavano was traded to the Montreal Expos (along with fellow prospect Tony Armas Jr.) in exchange for another pitcher—a pitcher named Pedro Martinez. (Courtesy Pawtucket Red Sox.)

Jason Varitek (right) and Derek Lowe (below) each arrived in Pawtucket at the same time after being traded from the Seattle organization in exchange for Heathcliff Slocumb on July 31, 1997. Each player spent barely a month with the PawSox and, since then, Varitek has emerged as one of the best all-around catchers in the majors while Lowe was an All-Star closer in 2000 and an All-Star starter in 2002. He pitched a no-hitter at Fenway Park on April 27, 2002, against Tampa Bay. (Courtesy Pawtucket Red Sox.)

At age 21, Juan Pena (left) was the youngest player in the entire International League in 1998. He had a league-leading 146 strikeouts that season and made history on July 22 when he threw a no-hitter at McCoy in a 5-0 win over the Durham Bulls. It was just the sixth no-hitter in PawSox history and the first in 11 years. He struck out 14 batters in the game and was mobbed by his teammates afterwards (below). (Courtesy Pawtucket Red Sox.)

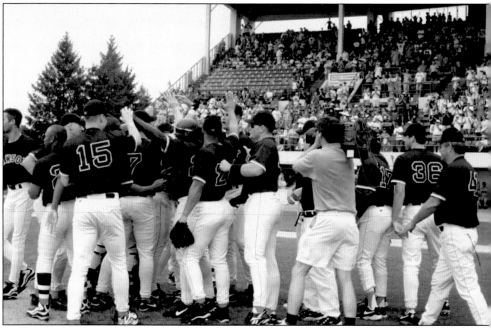

Trot Nixon had a breakout year for the PawSox in 1998. The former No. 1 draft pick led the team in nearly every offensive category: hitting (.310), homers (23), RBIs (74), and stolen bases (26). He became the first 20-20 player in PawSox history (20 homers and 20 steals), and Nixon's been a stalwart in right field for Boston ever since. (Courtesy Pawtucket Red Sox.)

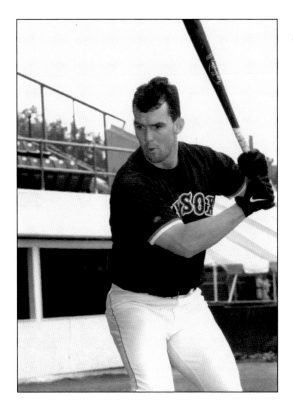

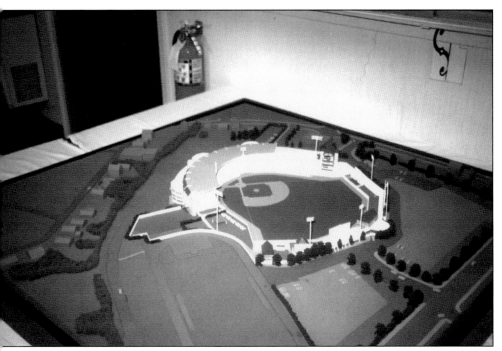

This is a model of what the new McCoy Stadium would eventually look like. Ahlborg/Heery was the design-build team behind the $16 million project. (Courtesy Pawtucket Red Sox.)

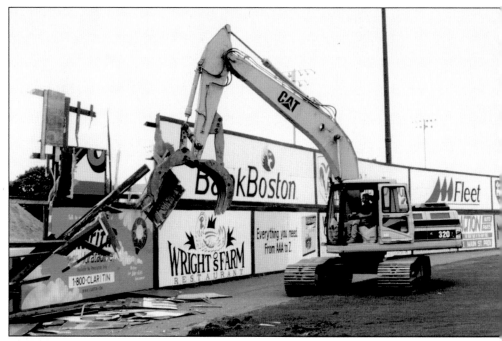

The McCoy Stadium renovation project actually began in March 1998, but work on the field could not start until almost immediately after the PawSox season ended in September. Here the old signage that lined the outfield walls gets torn down. (Courtesy Pawtucket Red Sox.)

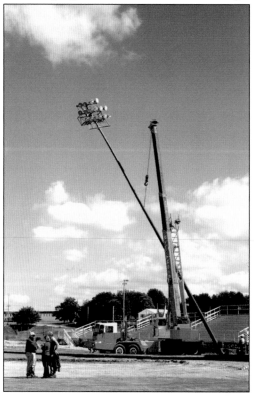

A crane pulls one of McCoy's old light towers from its roots. This tower was donated to a Coventry Little League field in honor of Joey Kuras, a talented young ballplayer who was tragically killed in a car accident. (Courtesy Pawtucket Red Sox.)

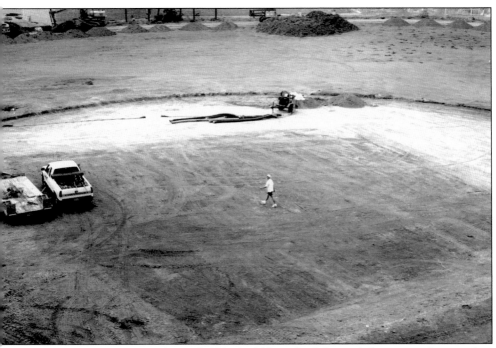

In November 1998, McCoy Stadium's field looked like a dirt bike track from up in the press box (above). Just a few months later (below), the ball yard was just about ready for action. (Courtesy Pawtucket Red Sox.)

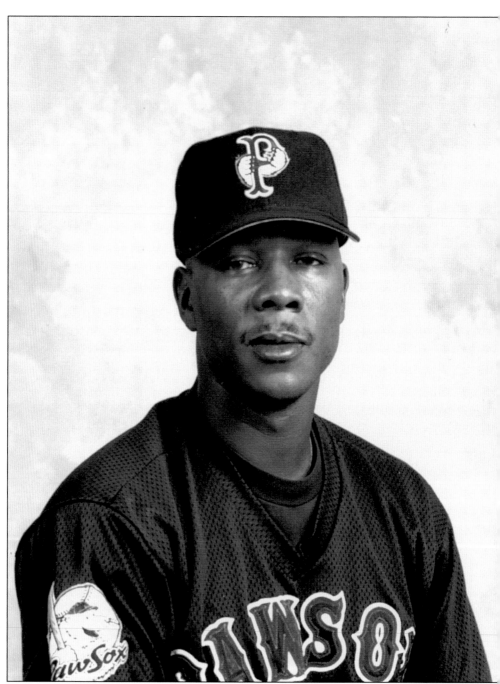

On November 5, 1998, Gary Jones became the 11th manager in PawSox history and the firs African American to hold the post. Jones guided Pawtucket to a 76-68 record in his debu season and to a franchise-record 82 wins the following year. However, the PawSox barel missed out on the playoffs both years and, after slipping to a 60-82 mark in 2001, Jones wa dismissed and became the organization's minor-league field coordinator. (Courtesy Pawtucke Red Sox.)

Four

THE NEW MCCOY STADIUM: 1999–2002

Although the Pawtucket Red Sox had established themselves as one of the most popular sporting attractions in New England by the late 1990s, McCoy Stadium was badly in need of a facelift. The old ballpark failed to meet Professional Baseball Agreement standards of a seating capacity of at least 10,000. Although McCoy was the very first professional baseball stadium to install a handicapped section, it still violated federal codes due to lack of access. If the PawSox did not make changes, they would have to leave McCoy.

And so, the McCoy Stadium renovation project was born. Spearheaded by Ben Mondor and Mike Tamburro, the $16 million project began directly after the 1998 season and was completed by April 1999. It was a smashing success.

Highlights of the new McCoy included increased seating, a new grandstand section and entry tower, a new playing field, and a new video board and scoreboards. A grassy berm behind the left field wall allowed fans to lie out on a beach blanket and take in a game from a new vantage point. McCoy's home and visitor's clubhouses were transformed into lavish areas, better than even the clubhouses at Fenway Park. Even the press box received a tremendous upgrade. In short, McCoy Stadium became one of the very best ballparks in all of professional baseball.

The fruits of the renovation project were immediately evident. The PawSox set a franchise attendance record of 596,624 fans in that 1999 season, the third highest total in all of minor-league baseball. After presiding over the successful project, Mondor was named Executive of the Year by both the International League (in a unanimous vote) and the *Sporting News* in 1999. In January 2000, Mondor was presented with the Judge Emil Fuchs Memorial Award for long and meritorious service to baseball, the Boston Baseball Writers Association's highest honor.

Two years later, the PawSox shattered their attendance figure again when 647,928 fans filed through the turnstiles at McCoy—even though the team stumbled to a 60-82 record, barely avoiding last place. In fact, success on the field has been limited since the new McCoy opened. The PawSox were in the playoff hunt going into the final weekend of both the 1999 and 2000 seasons but missed out both times. In 2001 and 2002, the PawSox struggled mightily.

There were highlights on the field: Tomo Ohka's perfect game on June 1, 2000, just the third perfect game in the 118-year history of the International League; Izzy Alcantara's 36 home runs in 2001, tying Jack Baker's franchise record; the announcement that McCoy will host the 2004 Triple-A All-Star Game.

The biggest reason why the fans keep filling McCoy Stadium is because the PawSox remain one of the best bargains in professional sports. Mondor has raised ticket prices just four times in his 26 years as owner, and McCoy continues to provide a warm, clean, and friendly baseball atmosphere with affordable ticket and concession prices for the entire family.

Play ball! The lights shone brightly on the new McCoy's opening night, April 14, 1999. A sellout crowd of 10,586 packed the renovated stadium to see the PawSox christen the new stadium with a 3-2 win over the Rochester Red Wings. The improvements of the new McCoy included increased seating, a new grandstand section and entry tower, a new playing field, new

video board and scoreboards, a grassy berm behind the left field wall, and vast improvements o the home and visitor's clubhouses as well as the stadium's press box. (Courtesy Pawtucket Red Sox.)

This is an aerial view of McCoy Stadium on opening night, April 14, 1999. Since the new McCoy opened up, the PawSox have set numerous attendance records. Entering the 2002 season, the top 34 crowds in the stadium's history had been achieved during the previous three years. The 35th-ranked crowd came in the Mark Fidrych–Dave Righetti match-up in 1982. (A.D., courtesy Providence Journal.)

With the new McCoy came a new mascot: Paws, the lovable polar bear that is a huge hit with the kids. Here, Paws pauses for a photograph in front of his own statue outside the stadium's main entrance. (Courtesy Pawtucket Red Sox.)

Among the popular attractions at the new McCoy is the berm that sits behind the left field wall. A grassy area where fans can stretch out on a picnic blanket and soak up the sun on a hot summer day, it is a great place for fans to view the game—and maybe even catch a home run. (Courtesy Pawtucket Red Sox.)

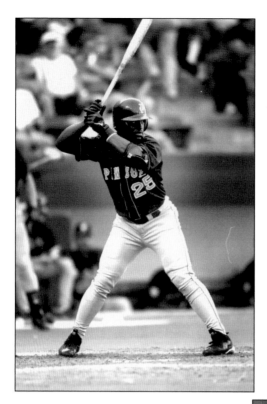

Michael Coleman had a huge year in 1999. The outfielder belted a team-high 30 home runs, was named the Red Sox' Triple-A Player of the Year, and earned a spot on the International League All-Star team. He was never better than on June 4 against Norfolk, when he hit for the cycle while going 7 for 7 in a 25-2 PawSox rout. (Courtesy Pawtucket Red Sox.)

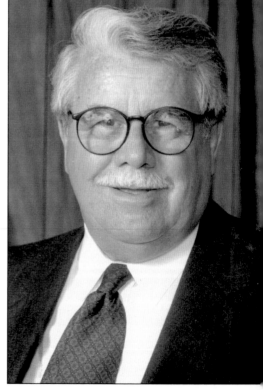

After shepherding the tremendous success of the McCoy Stadium renovation project, PawSox owner Ben Mondor was bestowed with multiple honors at the end of the 1999 season. He was named Executive of the Year by both the International League (in a unanimous vote) and the Sporting News. In January 2000, Mondor was presented with the Judge Emil Fuchs Memorial Award for long and meritorious service to baseball. (Courtesy Pawtucket Red Sox.)

Morgan Burkhart came out of the independent leagues swinging for the fences and enjoyed a couple of successful seasons with the PawSox. A modern-day Roy Hobbs, he slugged 3 homers in 2000 and 25 more in 001 while earning cups of coffee up in Boston during both seasons. (Courtesy Pawtucket Red Sox.)

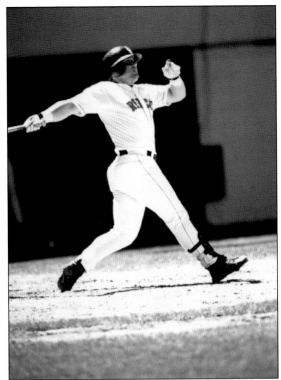

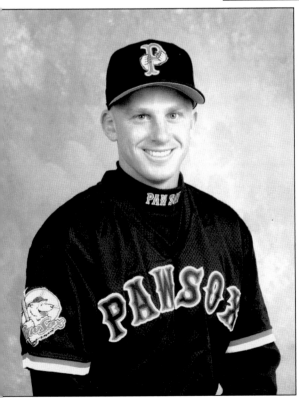

Diminutive David Eckstein was well known for his hustle while with the PawSox in 2000. Although he hit just .246, Eckstein showed flashes of potential, and the Anaheim Angels were happy to snatch him up when the Sox tried to sneak him through waivers on August 14. In 2001, Eckstein hit .285 as the Angels' starting shortstop. Despite his small stature, he ripped three grand slams in the first half of the 2002 season. (Courtesy Pawtucket Red Sox.)

Lightning struck twice for the PawSox in 2000, when two different pitchers threw no-hitters. On June 1, Tomo Ohka (left) made history at McCoy Stadium when he twirled a perfect game, just the third in the 118-year history of the International League and the first ever by a PawSox. Ohka needed just 77 pitches (59 of them strikes) to set all 27 Charlotte Knight batters down in order. On July 18, Paxton Crawford (below) hurled a no-hitter in Ottawa. It was not a perfect game, however, and it was accomplished over seven innings. (Courtesy Pawtucket Red Sox and B.A., *Pawtucket Times*)

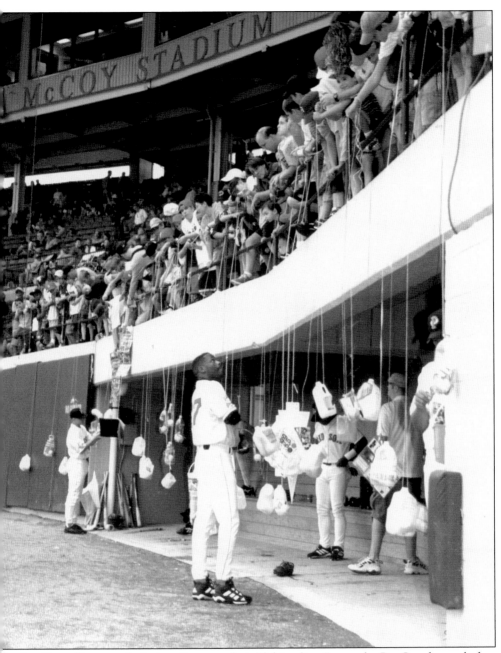

Pitcher Kevin Foster is the bait as fans cast their "fishing lines" over the PawSox dugout before a game in 2000. McCoy Stadium is the only second-story building in professional baseball, so young fans have to be creative to get autographs from their favorite PawSox players. For years, fans have been tying milk jugs, detergent bottles, lunch boxes, and so on to the end of long strings and "fishing" them down to the mouth of Pawtucket's dugout, where players find balls, cards, and other items inside to sign. (Courtesy Pawtucket Red Sox.)

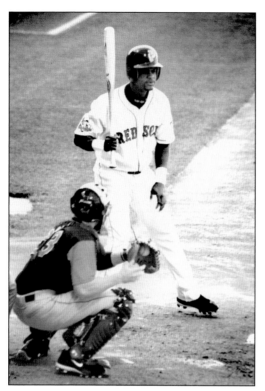

It was never boring when Izzy Alcantara (left) stepped up to the plate. There were the home runs: 36 in 2001, tying Jack Baker's franchise record, and 29 the year before that. The Dominican Republic native was named the PawSox MVP two years in a row (below, he accepts the award from manager Gary Jones in 2000). There was also the bizarre behavior: Alcantara was suspended by the league for six games in 2001 after he kicked Scranton catcher Jeremy Salazar to start a brawl on July 3 at McCoy. (Courtesy Pawtucket Red Sox.)

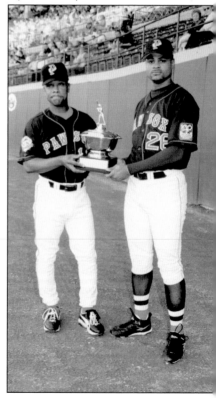

With one mighty swing of the bat on a June night in 2001, Juan Diaz forever etched his name in PawSox annals. Diaz blasted a home run that cleared the concession stand building in center field at McCoy and landed 491 feet from home plate. The Cuban-born slugger hit 28 homers in 77 minor-league games between Sarasota, Trenton, and Pawtucket in 2000. (Courtesy Pawtucket Red Sox.)

Rafael Roque was the PawSox' ace pitcher for much of 2001. The lanky left-hander (here signing autographs for fans) was the team's lone representative in the Triple-A All-Star Game in Indianapolis, although injuries curtailed his season and he finished 8-5. (Courtesy Pawtucket Red Sox.)

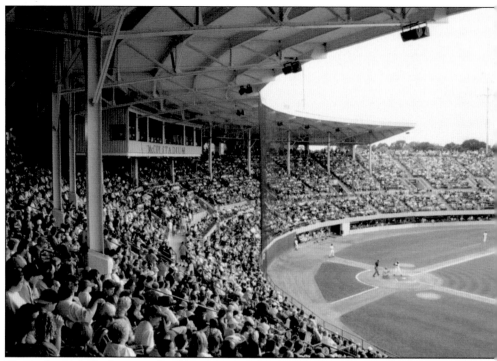

These photographs show another bang-out crowd at McCoy from both ends of the grandstands. In 2001, even though the PawSox finished 60-82 and barely avoided last place, they still set a franchise attendance record as 647,928 fans poured through the gates. It was the first time the club attracted more than 600,000 fans, and it was sixth among all minor-league franchises that year. In fact, the Boston Red Sox were the only professional sports team in New England to draw more fans than the PawSox in 2001. (Courtesy Pawtucket Red Sox.)

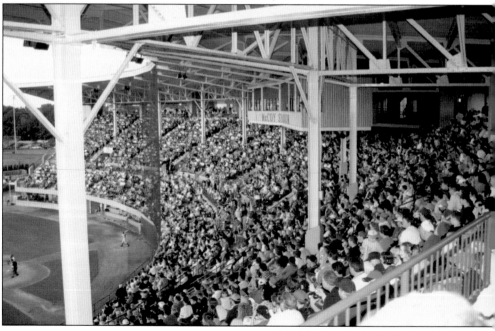

On December 7, 2001, the PawSox welcomed their "Buddy" back to the family. Buddy Bailey (second from left) is pictured here with (from left to right) Lou Schwechheimer, Red Sox director of minor-league operations Kent Qualls, and Mike Tamburro. Bailey returned for a second stint as the PawSox manager—the first man ever to do so. Bailey compiled a 286-281 record in his first four years (1993–1996) as Pawtucket's manager. (Courtesy Pawtucket Red Sox.)

The best and brightest stars of Triple-A baseball, the future Nomar Garciaparras of the world, will be gathering at McCoy Stadium in July 2004 for the 17th annual Triple-A All-Star Game. Here, Pacific Coast League president Branch Rickey III (left) and International League president Randy Mobley show off the official logo for the game. It is the first time that McCoy will host the event, which began in 1988. (Courtesy Pawtucket Red Sox.)

In June 2002, Boston Red Sox slugger Manny Ramirez made an 11-game rehabilitation stint with the PawSox. Ramirez was leading the American League in hitting when he broke his left index finger on May 11 against Seattle, but he did not have much success in Pawtucket. Ramirez hit just .100 (3 for 30) with one homer and two RBIs for the PawSox, but he was a hit at the box office. Pawtucket drew some of its biggest crowds of the season while Manny was in town. (B.A., courtesy *Pawtucket Times*.)

In 2002, the popular PawSox player murals returned to McCoy Stadium. For years, the murals of former PawSox stars like Oil Can Boyd and Mark Fidrych lined the outside walls of McCoy and were fan favorites. The murals were removed in 1999, and the original 45 were later donated to the Pawtucket Armory Association but were re-created using advanced digital technology and, along with 41 new murals, returned to the walls of McCoy in 2002.

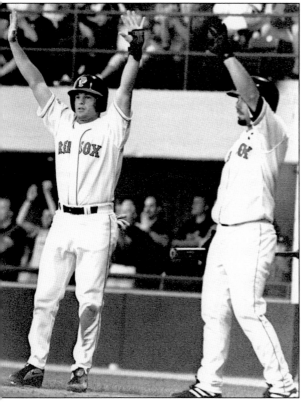

Who is the next future Red Sox star to hail from the PawSox? It could be Freddy Sanchez (left) or Angel Santos. Sanchez was promoted to Pawtucket on July 16, 2002, after tearing up the Eastern League with Trenton. Sanchez hit .328 with the Thunder, including a 27-game hit streak, and had reached base via either a hit or walk in 43 straight games. Santos earned a September call-up to Boston in 2001 after hitting .271 for Trenton and enjoyed a solid 2002 season with the PawSox. (B.A., courtesy *Pawtucket Times.*)

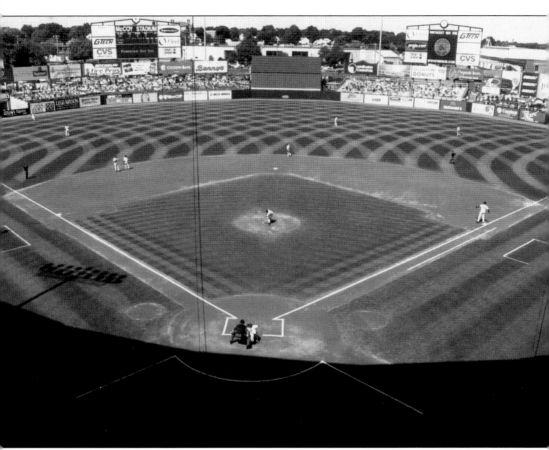

McCoy Stadium and the PawSox, on a sun-dappled summer day, remain a Rhode Island institution—not to mention one of the best bargains you will find in sports. The PawSox have raised ticket prices just four times in the last 26 years and continue to provide a clean, friendly baseball environment that is affordable for the entire family. (Courtesy Pawtucket Red Sox.)